MURDER & MAYHEM IN
ST. LAWRENCE
COUNTY

MURDER & MAYHEM IN
ST. LAWRENCE
C O U N T Y

8/7/2010

To Ang—

All the Best!

Cheri Farnsworth

C H E R I L. F A R N S W O R T H

Charleston · London
THE
History
PRESS

Published by The History Press
Charleston, SC 29403
www.historypress.net

Cover images from the Collections of the St. Lawrence County Historical Association and the author's personal collection.

First published 2010

Manufactured in the United States

ISBN 978.1.59629.964.1

Library of Congress Cataloging-in-Publication Data

Farnsworth, Cheri, 1963-
Murder and mayhem in St. Lawrence County / Cheri Farnsworth.
p. cm.
Includes bibliographical references.
ISBN 978-1-59629-964-1
1. Murder--New York (State)--Saint Lawrence County--History--Case studies. 2.
Murderers--New York (State)--Saint Lawrence County--History--Case studies. 3. Saint
Lawrence County (N.Y.)--History. I. Title.
HV6533.N5F37 2010
364.152'3092274756--dc22
2010022413

This book is dedicated to:

Marcia Scarborough
Adaline Scarborough
Marian Scarborough
Jean Macue
Sarah Jane Gould
Almon Farnsworth
Maria Shay
Mary Bartholomew
Kate Conroy
Joseph Kipp
Sumner Hazen
Jerry Apple
Elmer Crowder
Harry Hosmer
Henry LaDue
James LaDue
Harriet LaDue
Josephine Rogers
Dr. Theron Jenkins
Bessie White

CONTENTS

PREFACE

While every effort was made to obtain original photographs or sketches of each individual described in this book—museums, historians, newspapers and even prisons were all contacted—most of the images used in news articles written up to 200 years ago have long since been destroyed or lost. Neither the newspaper offices nor the various historians I contacted had any of the original images I sought of the criminals and their victims. Most of the county's voluminous newspaper archives have now been stored on microfilm or digitized and then discarded in an effort to free up space in facilities that once housed the brittle paper relics. And pages with photographs pertinent to this book were not scanned at nearly a high-enough resolution at that time to be of use to us for commercial print. So, in a few cases, I improvised. From my personal collection, I carefully chose original antique photographs of unknown individuals who closely resembled victims described herein, based on faded newspaper images and descriptive newspaper accounts. When such a photograph is used, the end of the caption will say: *Courtesy of the author.*

ACKNOWLEDGEMENTS

I'd like to thank my commissioning editor at The History Press, Whitney Tarella, and my project editor, Amber Allen, for their enthusiasm and expertise; also, the New England sales rep, Dani McGrath; Jamie-Brooke Barreto of sales and marketing; and my publicist, Katie Parry, and assistant publicist Dan Watson. They've all been an absolute pleasure to work with.

Many thanks to St. Lawrence County historian and executive director of the St. Lawrence County Historical Association, Trent Trulock; deputy St. Lawrence County historian and collections manager for the historical association, Sue Longshore; and JeanMarie Martello and others who staff the research room for their incredible patience and expertise in assisting with the extensive search for images found in this book. The historical association, located in the Silas Wright House on Main Street in Canton, is a vast wonderland for history researchers and enthusiasts. Trustee Stan Maine was kind enough to provide me with portions of his great-great-grandfather's diary, which proved useful to my story about Almon Farnsworth. The efforts of Mitch Bresett, special collections and archive assistant for the Owen D. Young Library at St. Lawrence University, were much appreciated, as well. I'm also grateful for the efforts of Jean Grimm, Town of Fine historian; Joe Lorenzo, Gouverneur Village historian and curator of the Gouverneur Museum; and Carl Stickney, Stockholm town historian and president of the board of trustees of the St Lawrence County Historical Association, who kindly met with me and offered his assistance.

The most gratitude goes to my husband, Leland Farnsworth II, for his unwavering encouragement and support of each book I write and to my daughters—Michelle, Jamie, Katie and Nicole—who keep me in the present and remind me of the inherently good side of human nature today, when too often I'm caught up in writing about the depraved deeds of our ancestors. I can never thank my parents, Tom and Jean Dishaw, enough for their continuous love and support; or my siblings, Tom Dishaw, Christina Walker and Cindy Barry. Other people who warrant special mention include my in-laws, Lee and Carol Farnsworth, and my sisters' families: Ed, Rachel, and Ryan Barry; Danon Hargadin; and Heather, Amanda, Bryan, Lindsey and Cade Alexander Walker.

INTRODUCTION

In 1816, when the first murder in this book occurred, St. Lawrence County was but an infant from a history standpoint—having been officially designated as its own distinct region just fourteen years earlier. In terms of land mass, this is hands down the Empire State's largest county, with 2,701 square miles. As such, there was much hostile ground to cover between the villages and hamlets that sprang up across the landscape throughout the 1800s and early 1900s. There were harsh winter-weather conditions to contend with; the few roads that existed were often impassable, due to snow cover and flooding; packs of roving wolves and panthers became such a threat to farms and homesteads that in 1871 a bounty was placed on the species to eradicate them from the region; and lawless marauders and transient vagabonds were as much a threat to the north country as anywhere, I suppose. Perhaps the most dangerous factor of all, however, in our county's early history, was not what its hardy and determined people endured out there, but, rather, the threats they often faced within the confines of their very own homes. Of the twelve sensational crimes I chose to include in this volume, more than half had elements of familial ties—crimes of passion, if you will. Others involved neighbors and trusted acquaintances. One was clearly a case of wrong place, wrong time. And two were never solved.

Wife and fiancée murders were surprisingly common in the nineteenth century, and the significant others who did the deeds were surprisingly inventive—not to mention cunning and coldhearted—in their *modus operandi*.

In 1857, James Eldredge, for example, slowly and deliberately poisoned his pregnant fiancée, Sarah Jane Gould of Louisville, under the guise of lovingly administering the medication the doctor prescribed to cure her—medicine that was later found to be tainted with arsenic. Van Van Dyke was still a teen when he was coerced into marrying young Mary Bartholomew, who was pregnant by another man. He shot and killed her a week after their wedding and claimed it was accidental; that he had been set up and his gun loaded without his knowledge. Frank Conroy sliced and diced his beautiful wife in Ogdensburg in 1897 after telling the constable to close the door and walk away. And the constable *did*! I've included all of their stories here. But there were many other similar stories that were not included, like the tragic case of Olivia Goodnow of Nicholville whose fiancé drugged her before allegedly attempting a crude abortion on the young woman that resulted in her tragic demise in 1901. He skipped town and was never found.

The women of this county's past were killed with poison, butcher knives, shotguns and operating paraphernalia by the hands of the ones they loved— and, in one case, by the feet of the one she loved. The *St. Lawrence Republican* of February 8, 1882, said:

> *A horrible murder was committed at Little Falls Sunday afternoon, when John Walsh kicked his wife to death in the presence of four of his children. It is now believed that the first wife of Walsh who was found apparently drowned eight years ago was also murdered.*

Maria Shay was five-months pregnant with twins when she arrived in Ogdensburg seeking assistance from two Canadian doctors for what she believed was a fibroid tumor. An inquest into her tragic passing revealed that she had bled to death after a procedure, and one of the two fetuses was later recovered from the river, stuffed inside of a cigar box. Bessie White was accosted near the old high school in Massena as she walked home one evening to her employer's house where she was a maid. Her bludgeoned body was discovered the next morning; but her killer was never found.

While innocent women like Shay and White were the frequent victims of murder in the county's criminal history, they weren't the only victims. Jean Baptist Gerteau (aka Louis Conrad) committed the Louisville ax murders in connection with a robbery in 1816; he not only slaughtered Marcia Scarborough, but also her infant daughter, Adaline, and his own brother-in-law, a boy who was staying with the family that night. Another young

daughter survived the attack. Poor old Joseph Kipp suffered an unspeakably excruciating and slow death after his much younger wife, their son and his wife's lover allegedly conspired to poison him near Star Lake in 1904. By the time he succumbed, the mucous membrane of his mouth and throat had all sloughed off from the acid he swallowed. Town of Hermon hotel keeper Almon Farnsworth suffered a fate like something out of an Alfred Hitchcock movie when he was fatally poisoned; his killer has never been brought to justice. Sumner Hazen was gunned down two days after his wedding to Callie Hall of Buckton near Stockholm in 1905, when her brother, John, became enraged at the prospect of losing her to another man—as if she belonged to him. John Hall then shot himself, leaving the young woman without a husband or brother. Rollin Dunning marched into his father-in-law's cottage on Black Lake in 1908, looking for his frightened wife who had left him. When she refused to return home with him, he shot her father and her brother-in-law dead. Each of these cases involved a killer who had been heavily drinking. But not so in the case of young Leslie Combs. Combs had just returned to the village of Fine in 1908 after serving time at the Clinton Correctional Facility (colloquially referred to as Dannemora), when he jumped Harry Hosmer, marched him down the road to his doom, beat him, robbed him and killed him—all for a few lousy bucks that he ended up handing over to police when he turned himself in.

"Tell them up North, I've got no hard feelings." Those were the last words of Alvah Briggs—alias Frank Driggs—before he was escorted to the electric chair at Sing Sing for the 1917 murder of brothers James and Henry LaDue; their sister, Josephine Rogers; and Dr. Theron Jenkins in Stockholm. What could possibly possess a man to launch an attack of that magnitude at the old Buck farm? His attorney asked the jury to believe it was "the sex frenzy," and therefore out of his control. Briggs claimed he did it because he wanted to carry away the LaDue's eighteen-year-old niece, Harriet, after brutally binding her to his bed and raping her. He even packed an away bag, of sorts, that included items like a frying pan and meat that he could use to keep the two of them alive for a few days in the deep woods near Potsdam. After the Buck farm carnage, it was learned that Briggs had come to the area a year earlier after serving time for raping a seven-year-old girl downstate. Indeed, a number of the murderers described herein were ex-cons who had served time at Dannemora or Sing Sing before being cast back out into northern New York territory, where they could wreak havoc on an unsuspecting, all-too-trusting rural populace.

In St. Lawrence County, the practice of capital punishment began in 1816, when Gerteau was hanged at Ogdensburg, which was then the county seat. The county seat moved to Canton in 1828 to better accommodate the greater population, and the sheriff then carried out hangings of convicted murderers at the county government complex, near the old smoke stack. But when the state prison system began using the electric chair for executions around 1895, the gallows were no longer needed in the north country. And, of course, capital punishment was abolished in New York state altogether in 1963. Thus, of the shady characters included in this book, Gerteau and Van Dyke were hanged; Eldredge died in prison before his death sentence could be carried out; and the others were either sent to the electric chair at Dannemora or Sing Sing or they served hard time and were later released.

The vast online Northern New York Historical Newspapers collection has been an invaluable asset to researchers, including myself, for the past few years. First-person accounts and courtroom proceedings transcribed at the time of a crime and recorded verbatim in newspapers of yesteryear are obviously far more accurate than information gleaned from the faded memories of someone who knew someone who was there 150 years ago. When details of sensational cases spanning centuries are retold generation after generation, each time a new individual passes on his understanding of the story, the facts become progressively more distorted until oftentimes the modern version bears little resemblance to the actual events as they occurred. Because the most recent murder in this piece occurred nearly a century ago, there is no one left alive today to interview for untainted, reliable, first-hand information; so *Murder and Mayhem in St. Lawrence County* is based primarily on original news sources and musty, old legal documents, which is probably as it should be.

Sadly, there are many more stories of murder—and certainly mayhem—in St. Lawrence County that I could not include here, such as the famous Howard Burt murder case of Hannawa Falls, the railroad bridge calamity between Massena and Cornwall in September 1898 that killed fifteen workers, or the slaying of Michael Daulter by Peter Bresnaham in South Colton, which I've written about in a previous work. Perhaps I'll elaborate on those three cases in another volume, if one should be forthcoming. For now, I give you a dozen carefully chosen, carefully researched historical murder cases that transpired over 100 years' time. All have earned a place in the annals of St. Lawrence County's criminal history.

SCARBOROUGH FAMILY MASSACRE

LOUISVILLE, 1816

SHOCKING MURDER—We understand that on Monday, the 12ᵗʰ inst. [sic]
*at Massena, in St. Lawrence County, a woman, her two children, one aged only
six months, and a French boy, were murdered in a shocking manner.*
*The author of this diabolical act is supposed to be a Frenchman who had an
antipathy against the family and took the opportunity, when the man was absent,
to murder his wife and children.*
The names we have not learned. The Frenchman has been taken into custody.
—Plattsburgh Republican, *February 24, 1816*

Michael Scarborough was born in Canada on January 6, 1785. He was one of the area's first settlers, arriving prior to the War of 1812 in which he served. After the war, he returned to his young wife and daughters on their sprawling Louisville farm near today's intersection of New York 37 and 56. Flynn's Broaster, once a popular local eatery, stood on this land until it was razed in a controlled burn in November 2006. It was there on Scarborough's estate—just past Stewart's on Route 56—that his family was nearly obliterated while he was away on business one ill-fated winter's day. Scarborough, who made a comfortable living running a lumbering business and store in the town of Massena, later told authorities that Jean Baptiste Gerteau (also known as Louis Conrad) must have noticed the large wad of cash he was holding while paying his men the day before the murders. He never dreamed Gerteau would rob him of it—or, far worse,

of his family—at the earliest opportunity, using any means necessary. The Frenchman, Gerteau, was one of Scarborough's employees who lived nearby. Somehow he knew the layout of the Scarborough home, where his young brother-in-law Jean Macue worked and was boarding; and he knew that Scarborough always kept money on hand. He even knew where to find it—or he had been told.

When Scarborough set out on February 21 for a few days, Gerteau hunkered down in his barn until the wee hours of the morning. Then he crept, scythe in hand, up to the door of the Scarborough residence and—apparently finding the door unlocked—stepped inside. There, just inside the door, he noticed an ax and replaced his scythe with it. How is it that the door was unlocked? Had young Macue been a willing accomplice to the burglary, unlocking the door and providing a floor plan to Gerteau, while entirely unaware that a simple robbery would escalate to a bloody attack on everyone inside, including himself? We'll never know. But according to author Gates Curtis in his 1894 *Our County and Its People: A Memorial Record of St. Lawrence County, New York*, Gerteau then "passed through the room where Macue was sleeping in a bed on the floor and entered the room where Mrs. Scarborough with her two children were sleeping." He snatched the money carefully from the corner of a drawer and turned to leave when one of several scenarios unfolded, as you'll see below. Some sources reported that he feasted on "cakes and sweetmeats" before fleeing on foot. At daybreak, neighbors went to the home and discovered footprints leading away from the house in the fresh snow. The door was then locked, so they peeked inside and, Curtis said, they "observed the corpse of one of the victims." Forcing the door open, they saw the full, horrifying scope of the crime: three people hacked to death, and one little girl lying in a pool of blood in critical condition. The authorities were summoned, and a search party set out and followed Gerteau's blood-dotted trail. They caught up to him about two miles south of St. Regis. On the grim journey back to the scene of the massacre, Gerteau admitted he was guilty and offered further details freely. He confessed that it required an entire bottle of whiskey to get up his nerve for the deed. And clearly he was still under the influence; for once he opened his mouth, there was no shutting him up, no matter how vile the atrocities he admitted to:

I raised dat axe up to strike der woman, but I could not do it. I say to myself, "Ah, mon Dieu, no!" I pull out de bottle from my pocket and take

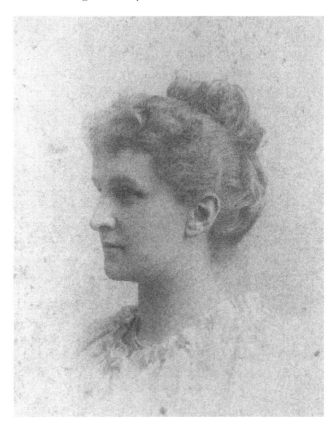

Courtesy of the author.

one big, big drink—put bottle back in pocket, and pick up axe. Den I strike—strike—and kill him woman and baby and boy, easy. [sic]

The only paper I was able to find that reported on the crime in 1816 was the *Plattsburgh Republican*. Most towns in the area did not have a local newspaper yet. Because the Plattsburgh media was basing its report on information relayed from across the miles—and because they had to throw something together hastily—some of the first details they published were inaccurate and much was considered unfit to print at the time or even decades later. L.H. Evert's *History of St. Lawrence County, New York* in 1878 said, "The details connected with this brutal tragedy are too horrible and sickening to relate." The unfortunate victims, it turned out, were Maria Scarborough, Michael's wife; their infant daughter, Adaline; and Jean Macue, who was only fourteen or fifteen years old. Three-year-old Marian somehow survived her wounds. The names of the parties in this tragic story have often been

spelled differently in various news articles (i.e. Macue/McCue/Manu, Maria/Marcia, Conrad/Conard, Gerteau/Grateau/Croteau, and Adeline/Adaline). I spell them here as they were most commonly reported in the earliest articles.

On March 2, 1816, a week after the paper had first announced the murder, the *Plattsburgh Republican* ran another article with additional details:

> *The murderer entered the room where Mrs. Scarborough, aged about 24, and her two children, a girl of 2 years and an infant of three months old, were asleep about 5 o'clock in the morning. He struck Mrs. S twice across the neck with an axe which nearly severed the head from the body. The infant had a blow on the head with the head of the axe and died in about* [illegible] *hours. The little girl is said to have 3 marks of the axe on her head and one on her shoulder, but hopes are entertained for her recovery. He then went into the room where the French boy lay…* [and] *struck him with the axe and cut his throat.*
>
> *Having taken these murderous precautions to prevent detection, he broke open a trunk and took from thence 22 Dollars and 3 cents—he expected to have found 500 Dollars.*

Franklin Benjamin Hough offered a different take in his 1853 book, *A History of St. Lawrence and Franklin Counties, New York*. He said Gerteau killed his victims *after* he found the money he was looking for, not before like the *Plattsburgh Republican* reported. "He might have made his escape unobserved; but fearing detection, laid [the money] down, raised his weapon, and with a blow, nearly severed the neck of the woman." The *St. Lawrence Republican* of December 14, 1881, relates two other versions in "The First Execution in St. Lawrence County." The first was given by Mrs. Scarborough's niece and published in the *Antwerp Gazette* in 1881. She said that when Scarborough left for Montreal, he left Jean Macue to stay with his wife and children; and it was expected that Gerteau would return to his own house nearby. Instead, Gerteau hunkered down in Scarborough's barn, unbeknownst to anyone, and began his killing spree only when he was caught in the act of burglarizing. She also pointed out that Gerteau admittedly killed a nephew out of greed years before the Scarborough family massacre:

> *The next morning, neighbors noticed there was neither smoke nor stir about the house and barn, and, going over about 10 a.m., found the doors locked*

and a man's track leading from the house. On looking in, they saw a young Manu [sic] lying dead upon the floor. Breaking into the house, they found Mrs. S. and two children chopped to pieces in the parlor bedroom, while a third child, Marian, had a fearful gash across her face, but was alive, and recovered, and is still living. Mr. S.'s desk had been broken open and a small trunk, usually containing money, was gone. Parties immediately followed the track…and he, going through byways and lots, was soon overtaken. When he saw the men, he threw the trunk into some brush, but…told where to find the trunk, which, on opening, was found to contain 75 cts. He said he stayed around the barn all day and at night went into the cellar and ate as hearty a meal as ever in his life; he then took an ax and started to break the desk open, but found they were sleeping there, instead of in the usual rooms. Manu awoke as he entered, and he laid his head open with the ax. After splitting open the desk, the babe nestled around and awoke the mother; then he killed all as he supposed. He confessed he had also killed a little nephew years before, that he might inherit the property.

Joseph Fields, a neighbor, was allegedly the first man who came upon the crime scene, so he was intimately familiar with the case. His son, David, told the *St. Lawrence Republican* his father's account of the incident sixty-four years after it happened. In this version, a boy was lifted through a window into the Scarborough residence by a crowd that had gathered to see why nobody was answering the frantic rapping on the windows and door. He returned with the grim news:

[Fields] *had made arrangements with Mr. Scarboro [sic] for the use of a couple of ox teams for the purpose of getting in his supply of firewood, and started before daylight to go to Mr. Scarboro's for them. It was a bright moonlight morning, but had snowed during the night. As he approached the Scarboro residence, he discovered tracks of a man, leading away from the premises. The cattle in Mr. Scarboro's barn were making piteous indications of distress, and Mr. Fields went into the barn and fed them. He then went to the house and found the tracks led from the house to the barn. He found the house locked, and it was impossible to waken the inmates. He then suspected something was wrong. He went to the bedroom window where the family slept and rapped. There was no response. He then alarmed the neighbors, and when a number had gathered, a window was forced open and a boy sent in to see what was the matter. He soon returned and reported*

all the family dead. A pursuing party was organized, of which Mr. Fields was one. They took the track and in a few hours Gerteau was overhauled making his way to St. Regis. His hands and arms were red with the gore of his victims.

One thing all accounts agree on is what transpired after Gerteau was apprehended and arrested. He was tried at the county courthouse in Ogdensburg on July 3, 1816, with the honorable judge William W. Vanness presiding and pleaded not guilty to the three indictments against him. But the jury found him guilty of murder on all counts and sentenced him to be hanged in nine days. It would be the first execution in St. Lawrence County's history. The court records from that day, according to Hough's *History*, say, "Louis Conard, otherwise called Louis Gerteau, otherwise called Jean Baptiste Gerteau, for the murder of Maria Scarborough, whereof he was convicted, was called to the bar, and the court sentenced that he be taken to the place from whence he came, and from thence to the place of execution, and that on Friday, the twelfth instant, between the hours of one and three, to be hung by the neck until he is dead, and may God have mercy on his soul; and further, that his body be delivered to the medical society of this county, to be delivered to some person authorized to receive it."

The twelve-foot, hinged platform of the gallows was propped up by an upright post at one end and secured by a cord, or rope, at the other end. On July 12, 1816, before a large crowd that had gathered around the gallows, Gerteau was led onto the platform and the end of a rope hanging from a tree limb was adjusted snuggly around his neck. Sheriff Joseph York's solemn duty was to cut the cord supporting the platform with his sword, thus causing the platform to collapse and the killer to plunge. But when York, undoubtedly shaken by the monumental task his title required of him, rode up on his horse and swung his sword at the cord, it refused to cut, even after several attempts. Was it a dull blade or poor aim? Who knows? But, finally, he was forced to get off his horse and approach the gallows on foot with a hatchet. Slowly, thread by thread, the blows of the hatchet worked their way through the stubborn cord, fraying and weakening it until it finally let go, and Gerteau was left dangling and struggling before the horrified crowd who had never seen a man strangled to death so slowly before—or at all. Had the rope been severed with one swift whack of the sword or hatchet, as was expected, Gerteau would have died instantly from a snapped neck. Perhaps, considering his crimes, some might have felt the slow, painful death

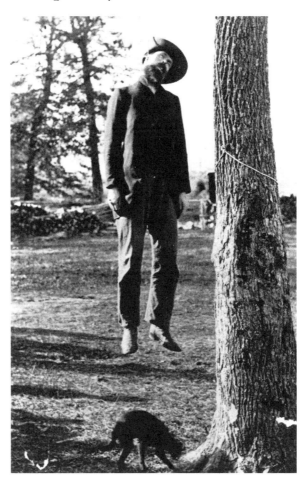

Courtesy of the author.

he endured was in order. But the sheriff would have none of it on his watch and famously yelled, "For God's sake, cannot someone put this man out of his misery?"

A young physician from Lisbon was up to the task. He happened to be standing right next to the suffering man, so he grabbed Gerteau's feet and gave a violent downward yank, causing the noose to tighten and break the man's neck. The doctor's actions infuriated the crowd, according to many sources. However, none explained if this anger was directed at the doctor because he took another's life with ease or if they were upset that they didn't get to see the prisoner writhe in agony a bit longer. Nevertheless, that physician's medical career was over the moment he stepped up to the plate. According to the *Massena Observer* of September 25, 1924, Gerteau's body was then

hurriedly cut down and laid out on a nearby table. No mention was made of the customary counting of respirations or pulse to ensure death was certain and absolute before the doctors began dissecting him. In fact, the article states that the first incision was made "while the flesh was yet quivering."

The site of the hanging was at a tree in the city commons facing Washington and Elizabeth Streets in Ogdensburg. In "Reminiscences of the Burg," dated January 24, 1871, the *St. Lawrence Republican* told of the fabled oak under which Gerteau met his fate:

> *Near Myron Hickock's, in Washington Street, were the remains of an old stump famous in the legendary lore of the boys for marking the spot where Louis Baptiste Gerteau, the first man executed in St. Lawrence County, was hanged. The law foreclosed and his "checks were passed in" on the 12th day of July, 1816. This was ten years before our debut here, and of course what we remember of that event, we inherit from our parents, both of whom witnessed the execution. His crime was the murder of Maria Scarborough, her infant and a lad aged fourteen or fifteen, named Macue, near the village of Massena, in the town of Louisville, on the 22nd of February, of the same year. After execution Gerteau was given to the doctors and his bones picked. For many years, his skeleton was in the possession of Dr. Smith, long since deceased, and, we believe, is now in the office of Dr. S.N. Sherman. The bones of this first murderer of St. Lawrence County were the bugbear of many a boy's "nightly vision." If they did not keep us in at nights, we travelled lively wherever we were required to go alone.*
>
> *The old stump remained till expansion had carried the village line down to Patterson Street and the plow and scraper had thrown Washington Street into a well-rounded turnpike.*

Although scarred for life from the physical and psychological trauma she endured, little Marian Scarborough grew to adulthood and married William Monroe of Canada. She was blessed with two sons and a daughter. Patriarch Michael Scarborough lived until he was ninety-three years old, dying in 1878. His second wife, Mary A. Marsh of Cornwall, Ontario, died ten years after him. Eventually, the Scarborough Farm became known as the Casaw Farm, while Amab and Armenia Newgal Casaw lived there from the 1860s until about 1909. The corner has long since been commercially developed, making it difficult to fathom the horrific crime that stigmatized the property so long ago.

THE ARSENIC POISONING OF SARAH JANE GOULD

LOUISVILLE, 1858

While pretending to her and her friends that you was [sic] *the devoted lover and faithful nurse, you was her cold-blooded assassin.*
—*Judge James to murderer James Eldredge*

James E. Eldredge was just twenty-one years old when he became a cold-blooded killer. He was born in Canton. After a brief stay in Iowa—where his family moved in the spring of 1856—he returned to the area, settling in Louisville under the name of Edwin Aldrich. He quickly acquired work as a teacher and was allegedly a very fine one, at that. When school closed in March 1857, Eldredge moved into the home of Louisville resident Danforth Britton. As fate would have it, Britton's niece—Sarah Jane Longhey Gould—was living with Britton and his wife at the time. Sarah was the oldest of four children; and her parents died when she was very young. She married John Gould at nineteen and was widowed in 1852 at the age of twenty-one. Eldredge set his sights on the lovely young widow, and their courtship quickly progressed to the point of discussion of marriage; some believed that Eldredge had only promised to marry Gould so she would agree to premarital intimacy with him. As the engagement progressed, Eldredge sank further into debt with Sarah's uncle, not only for his room and board, but also for items he had purchased at Britton's store. He kept putting Britton off by insisting he would pay him in full as soon as he received the large sum of money he was allegedly expecting at any moment from his family out west.

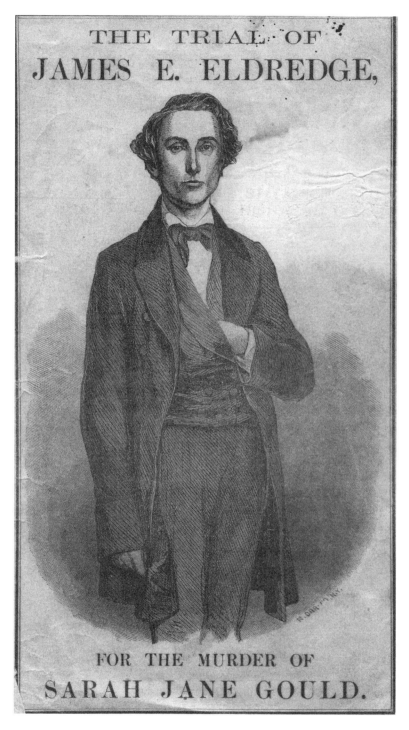

James Eldredge. *Courtesy of the St. Lawrence County Historical Association.*

The Arsenic Poisoning of Sarah Jane Gould

Mrs. Britton first suspected Eldredge was lying about the money when she searched his carpetbag one day after finding the key to the bag on the floor in his room. She had hoped to find letters from his family corroborating his story about money being on its way, but no such letters were found. Instead, she discovered a package of arsenic from the H.S. Humphry & Co. Druggists in Ogdensburg. Sarah was suffering from a cold at the time and taking cough syrup for it. The bottle of syrup was kept in the sitting room that adjoined Eldredge's bedroom. Then, on May 25, 1857, Sarah became violently ill with symptoms resembling acute poisoning, vomiting bile and a "dark greenish substance," according to reports. She believed the cough syrup was making her sick and was moved into Eldredge's room because of its proximity to the sitting room; the family could keep a closer eye on her there. A physician was called to the home and prescribed medicine that worked well to reverse the course of her sudden ailment, at least initially. Feeling confident that Sarah's condition would continue to improve as long as someone stayed by her bedside carefully administering the remedy as prescribed, the physician agreed to let her fiancé take over the important task; Eldredge seemed genuinely concerned as he doted on her, insisting on providing sole care for her. But Sarah's mysterious ailment, which had improved in the doctor's presence, only worsened with Eldredge by her side. On May 30, after five agonizing days of suffering, Sarah Jane Gould died. As the last person to see her alive and the only person responsible for her treatment during her rapid decline, Eldredge fell under suspicion well before all the pieces of the puzzle started coming together.

Though Mrs. Britton had seen the container of arsenic in Eldredge's bag just two weeks earlier, it was missing when she checked the bag during Sarah's precipitous decline. After the death, the arsenic from the bag was found on the shelf in the sitting room—the same room in which Sarah's cough syrup had been stored. Upon closer inspection, white sediment believed to be arsenic was found on the bottle of Liverwort Tar cough syrup, and the unfinished medicine the doctor had ordered to counter the effects of apparent poisoning was examined. By then, the bottle should have been empty. Yet, far more damning to Eldredge than the fact that he hadn't administered all of the medicine as instructed was the fact that traces of white oxide of arsenic were found mixed into what remained of Sarah's medicine. In fact, the medicine had been laced with enough arsenic to kill several good-sized men. Eldredge was brought in and arraigned before M.A. Moore, Esq., and charged with the murder of Mrs. Gould. At that, he attempted to kill himself with arsenic

hastily poured into a glass of water he had been drinking. But he swallowed so much in one gulp that he immediately vomited; thus, accidentally saving himself. With evidence of arsenic poisoning solidly established, Sarah's body was exhumed by the coroner's jury. It was then that "unmistakable traces of the presence of arsenic" were found in her stomach; and, according to the *St. Lawrence Republican* of June 16, 1857, "A post mortem examination revealed the fact that she was *enceinte* [pregnant]." Was that what this was all about? Was that Eldredge's motive for the crime? If he never planned to marry Sarah at all, as some believed from the start, did the daunting realization of impending fatherhood scare him to the point of murdering his pregnant mistress?

On December 23, 1857, after an "intensely exciting and interesting trial," Eldredge was found guilty by a unanimous jury and sentenced to death, according to the *St. Lawrence Republican* of January 5, 1858—but not before he expressed his innocence to the court in Canton, as follows:

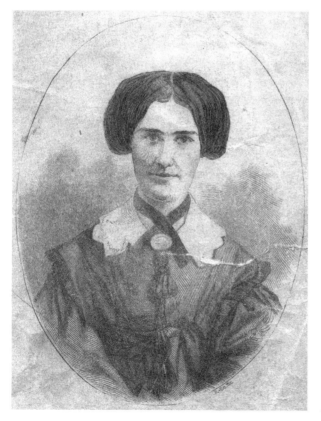

Sarah Jane Gould.
Courtesy of the St. Lawrence County Historical Association.

BY THE COURT

Prisoner, stand up. Have you anything to say why the sentence of the law should not be pronounced upon you?

SPEECH OF THE PRISONER

I don't know that I have. I am innocent of the crime charged against me. Almost every act I have done, and word I have said, for the last year, have been proved against me—and many things I did not suppose evidence—and things look dark against me. I have no doubt most all these people here think I am guilty, and I do not know as I can blame them; but if I could have a chance, I could prove things different. I don't know but my counsel can get a new trial, and I don't much care, for I don't think it would do me any good. For myself, I don't care for a new trial—but, for my father and mother's sake, I would like to have some things cleared up.

Unmoved, Judge James then offered his lengthy sentencing speech:

SENTENCE BY JUDGE JAMES

It now becomes the solemn duty of the Court to fix the period of your earthly existence. This is a great power—one which, in the ordinary course of nature, is only exercised by God himself.

In the exercise of that power, the Court acts not as individuals, but as agents of the civil government of the State.

You have been convicted, by a fair and impartial jury of your own county, of the murder of Sarah Jane Gould.

No doubt every juror would have rejoiced, could they have seen a way consistent with their oaths, to have acquitted you of the charge; but the proof was too strong; and, after careful consideration of the evidence and all its bearings, the Court do not see how any other verdict could have been anticipated.

Yours is a dreadful crime and shows great depravity of character. Your victim, a young woman in the prime of life, was one whose affections you had won under a false name, and with false representations of your name and standing. One whose love you had gained and, by promise of marriage, betrayed. Having satiated your passions, you thought you'd rid yourself of your victim and escape the exposure of the duplicity you had practiced upon her. Perhaps you sought another victim in the sister.

With your own hands, you administered the fatal poison and, from day to day—unmoved by pity, unstung by remorse—watched the agony she endured.

When she appeared better—under the pretense of administering the medicine—you again mingled with it the deadly powder; and, thus, while pretending to her and her friends that you was [sic] the devoted lover and faithful nurse, you was [sic] her cold-blooded assassin.

For five full days, you stood by and saw her writhe in agony and sink in death—receiving from her, in her last moments, the expiring kiss of a fond and faithful heart.

The atrocity of the murder was never yet equaled. When charged with the crime, the fear of human justice overcame you; you attempted a double murder, and thus sought to rush unbidden into the presence of the Deity, that you might escape the vengeance of human law.

During the few remaining days you have to live, let me urge upon you to improve the time in preparation for death—to seek that forgiveness which can only be obtained by repentance and prayer.

I would advise you not to rely much that your execution will be stayed by a new trial. When your counsel come to consider the case, after the excitement of the trial has passed, I feel quite confident that they will tell you there is no hope in that quarter. It is then your solemn duty to prepare for death.

We have consulted together and have fixed, as the day for your execution, the 11th day of February next.

The sentence of the law, therefore, is that on Thursday, the 11th day of February 1858, between the hours of 12 and 2 o'clock in the afternoon, within the walls of the County Jail of the County of St. Lawrence, you be hanged by the neck until you are dead.

Due to procedural questions, the execution was delayed for over a year. By December 1858, Eldredge had meanwhile become so ill that physicians didn't think he would survive much longer. It was believed he was possibly suffering from a latent reaction to the lethal dose of poison he had given himself a year earlier, so the suggestion to let him stay with friends rather than remaining in jail was being considered. The case was appealed, and a new trial was ordered to be held in early 1859 in Saratoga County because of the immense publicity the case had generated in St. Lawrence County, which made a fair and unbiased trial all but impossible. As the doctors had feared, however, Eldredge didn't survive long enough to be tried. On February 22, 1938, an elderly resident of Dekalb Junction told the *St. Lawrence Plaindealer* that Eldredge had committed suicide by unspecified means at the county jail

in Canton. Whether or not his death was self-induced—because he never wavered in his proclamations of innocence and because his second trial never saw the light of day—the whodunit rumor mill went into full swing. While most believed he was guilty as charged, some thought otherwise.

Three years after Eldredge died, a man named D.J. Chrichton got himself into a whole heap of trouble for repeating a rumor he heard that Sarah's uncle had given a deathbed confession to the murder of his niece. Not only was Britton still alive at the time, but no such confession was ever made. Nevertheless, the rumor spread like wildfire after Chrichton repeated it in Potsdam to several people. Britton had an attorney file a lawsuit against Chrichton for slander and said it would only be dropped if Chrichton could provide a name to Britton's attorney from which to trace the rumor to its origin. Chrichton was unable to do so, but he did submit a public statement of apology to the *St. Lawrence Republican* which was published on February 4, 1861, in hopes that it would suffice.

Eleven years later, in May 1872, another rumor surfaced of a deathbed confession regarding the crime; this time it had *Mrs. Britton*, Sarah's aunt, as the villainess. The *Canton Plaindealer*, in sharp response, issued the following release which was also published in the *St. Lawrence Republican*:

> *MURDER WILL OUT—A startling statement is received here concerning the Gould-Eldredge murder case. Of course nearly all of our readers are acquainted with the previously-known particulars of this terrible affair…Eldredge was convicted and sentenced to be hung, which sentence would undoubtedly have been carried out had he not died of sickness. S.J. Barber, DDS, formerly of this place, now of Burlington, Vt., has written to his brother, John Barber of Canton, that he was recently informed by a physician of his acquaintance that the woman who gave such strong evidence against Eldredge died a short time since; that on her death-bed she confessed that she placed the arsenic in Eldredge's satchel, and that she was the poisoner of Sarah Jane Gould. This confession was made in the presence of an attending clergyman, who is a brother of the physician above mentioned. Dr. Barber promised in his letter to give us further particulars as soon as he could obtain them, which we, in due time, will give to our readers.*

The editor of the *St. Lawrence Republican* was quite upset—"grossly imposed upon," as he put it—over the latest rumor, calling it a "mean and

malicious falsehood." As in the case of the alleged deathbed confession by Mr. Britton in 1872, Mrs. Britton, who purportedly confessed to the murder in this report, was also still very much alive. The newspaper editor said that whether the bogus claim "rests with Mr. John Barber of Canton or Dr. S. J. Barber, or the mythical 'physician of his acquaintance,'" the individual responsible for concocting such a statement was "to say the least, a very bad man." Thus, fifteen years after the sensational murder of Sarah Jane Gould and the death of the man believed responsible, the question of James E. Eldredge's guilt persisted.

ALMON FARNSWORTH'S DREADFUL DEATH

HERMON, 1872

Strychnine. Ugly way to die.
—*Sheriff Al Chambers in* Psycho

There's a reason strychnine is often used as the poison of choice in horror films like Alfred Hitchcock's *Psycho*, in which Norman Bates's mother and her lover were each killed with it. The crystalline alkaloid causes some of the most bizarre and excruciating symptoms of any known poison. Today, it's found primarily in pesticides, like rat poison, and is not used medically; but strychnine was once used in very small concentrations as a stimulant and to treat constipation and stomach ailments. Typically, ten to twenty minutes after ingestion of a lethal dosage, the victim becomes agitated and apprehensive, as a result of the drug invading the central nervous system. The head and neck soon go into muscle spasms that quickly infiltrate every muscle in the body. These spasms and convulsions increase in intensity until the victim's neck stiffens and his back becomes arched rigidly—only his head and heels remain grounded. As the body seizes up, so, too, do the neural pathways that control breathing. The victim, therefore, dies from either suffocation or from the sheer exhaustion of his ordeal. One of the most disturbing features of strychnine poisoning is that it causes the body to go into instantaneous rigor mortis at the moment of death, locking into a convulsed, open-mouthed position with the back arched unnaturally and eyes bulging in mortal fear. Such was the horrific scene at the Farnsworth House hotel and saloon in Hermon one night long, long ago.

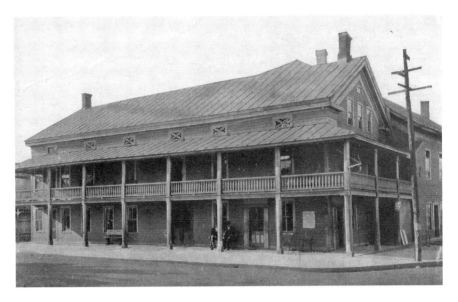

Farnsworth Hotel, later called the Hermon Hotel. *Courtesy of the St. Lawrence County Historical Association.*

The evening of January 22, 1872, was busier than usual at the Farnsworth House. Hotel keeper Almon Farnsworth visited with regulars while welcoming patrons who arrived for an appointment with a traveling phrenologist; the head reader was doing examinations in the sitting room at the hotel. But while the phrenologist was busy illustrating how the shape of the one's skull could reveal one's true character, one or more men in the crowd were plotting a murder that would interrupt the fun in short order. Justice of the peace Clark Maine wrote in his diary for that day, "Had talk with A. Farnsworth, took supper, F. took me home at 8 P.M. [*sic*]." He couldn't have known it would be the last time he saw his old buddy alive.

At about 8:15 p.m., a Mr. Schofield went into the barroom for some beer and took nearly all that was left in the pitcher. Theron Farnsworth, one of the owner's sons, then filled the pitcher about two-thirds full and set it on a shelf under the counter as a courtesy to the next patron. Shortly after 9 p.m., after a long, hectic day running his business, Almon Farnsworth walked behind the bar and grabbed the same pitcher. It was time for a drink. Pouring himself a glass of beer, he guzzled it down and returned to the sitting room to watch the phrenology exams and relax. From the first bitter sip, an uneasy tingling sensation washed over him, spreading to every limb; he was having seizures within minutes. Dr. E.G. Seymour of Hermon

rushed to the hotel and found Farnsworth convulsing and near death, but the victim was able to blurt out that he had just taken a drink that was poured from the pitcher. Around 9:30 p.m. Farnsworth was dead—it happened that quickly. Seymour ordered Farnsworth's sons, Theron and Amos, to secure the pitcher and tumblers from which their father drank, which they did immediately, and Coroner J.R. Furness was summoned to the scene. He and Seymour concurred that the cause of death resembled strychnine poisoning, so the coroner fed some of the tainted beer to a cat to test their theory. Sure enough, the contaminated brew "produced death in ten minutes," according to the *St. Lawrence Republican* of January 30, 1872. After comparing the chemical composition in the beer to the stomach contents of the deceased, the coroner ruled that "the said Almon Farnsworth came to his death on the evening of the 22d of January 1872 by strychnine, taken in beer, from a pitcher used in the bar of the Farnsworth House in Herman, N.Y.; [and] that said strychnine was placed in said pitcher by some person or persons to the jury unknown."

While death usually occurs within three hours of exposure, in Almon Farnsworth's case, it came after just a half hour—and, in the cat's case, it came in only a few torturous moments. This means that whoever put the strychnine in the beer knowingly used enough poison to leave no room for chance. They wanted someone dead with absolute certainty, whether the intended victim was the poor old hotel keeper or another man altogether. The investigation would show that a number of men shared the pitcher that evening and had access to the bar, so the finger-pointing and wild speculation began. Portions of the justice of the peace's diary that were provided to me by his great-great-grandson, Stan Maine, give glimpses in the first person of what transpired over the next two weeks, beginning with Clark Maine being summoned to the scene by the county sheriff, J.F. Daniels, the following morning:

> *Tuesday Jan 23—J.F. Daniel came after me near 10 A.M. on account of death of A. Farnsworth.*
>
> *Wednesday Jan 24—9 A.M. attend coroner's inquest; got home about 12 o'clock night.*
>
> *Thursday Jan 25—9 A.M. met coroner's jury; closed up after 12. Attend funeral P.M.*
>
> *Monday Jan 29—Went to village, talked over murder case with many. Got up in night and [completed a] warrant for O. Brown.*

Tuesday Jan 30—Got to [village] 7 A.M.; waited till Brown arrested.
Wednesday Jan 31—Attend [examination] of Brown; got home midnight.
Thursday Feb 1—Attend [examination] at 9; got home 12 P.M.
Friday Feb 2—Same as above.
Saturday Feb 3—Assisted [examination] till 12; got home 4 pm.
Wednesday Feb 7—The people vs O. Brown; got home 11 P.M.
Thursday Feb 8—The people vs O. Brown, got home 9 ½ P.M.

Oscar Brown was indicted when it was learned that he had an unsettled account with Mr. Farnsworth and owed him a large amount of money that the two had been arguing about. To make matters worse, a witness testified that he saw Brown buy a package of poison from Mr. Healy, the druggist, the previous summer. According to the *St. Lawrence Republican* of February 6, 1872, the witness said he "saw Mr. Healy doing up a package about the size of two fingers, which he handed to Oscar Brown, and immediately took it back, remarking, 'Here, let me mark that poison, so you will have no trouble with it.'" The package was wrapped in white paper. But Mr. Healy, when questioned, had no recollection of ever preparing such an item for a customer. Thus, Brown was acquitted, and all eyes fell on three remaining suspects: Theron Farnsworth, Amos Farnsworth and Halsey Smith. A witness named Marshall Reed—whom one paper called exceedingly illiterate—claimed to have been looking in the window of the hotel just before nine o'clock that evening when he saw Theron pick up a pitcher from under the counter and set it on the bar. Smith, he said, then "took from his pocket a small paper which he opened and shook a white powder into the pitcher," and another witness testified that he knew Smith had some type of poison in his possession at one time to allegedly kill foxes with. But Reed never mentioned what he saw during the coroner's inquest, when all potential witnesses were urged to come forward. He waited until the eve of Brown's trial to come forward, when he became convinced that the murder might be pinned on his buddy, Brown. Thus, Reed's story was destined to be thoroughly debunked. Several other witnesses also saw Smith and Farnsworth's sons standing behind the bar at various times that evening. But one of the perks of having a parent own a bar is that you get to go behind the counter and help yourself. (I should know.) Ira Williams said he saw Smith and Theron whispering to one another in the wash room shortly before all hell broke loose that night, but he didn't hear what they were saying. Again, it meant nothing; they could

have been whispering that Williams was an idiot, for all he knew. If either of Farnsworth's sons who were at the hotel that night had anything to do with their father's demise, wouldn't they have dumped the contents of the pitcher and tumblers right down the drain when they were told to secure them? It would have been a no-brainer to eliminate the evidence. The drain was right there beside the pitcher, behind the counter and out of the doctor's view. But they did as told; and they did it without hesitation—like any innocent person would have.

Halsey Smith was a person of interest, not just because of his association with the Farnsworth sons that evening and the witnesses' various claims, but also because he had fired a pistol at Mr. Farnsworth the previous summer from across the street, narrowly missing the hotel keeper. Smith insisted it was nothing more than a practical joke; that if he had really wanted to hit him, he could have and he didn't. Nevertheless, he, Amos and Theron Farnsworth were all indicted by the grand jury and held together in the county jail in Canton to await trial in late March 1874. Amos, a farmer, was twenty-eight years old; Theron, a printer and foreman of the *Sun & Recorder* in Rome, was just twenty-two; Halsey Smith was around thirty. He was a shoe maker in Hermon. All were well respected in their communities. At the

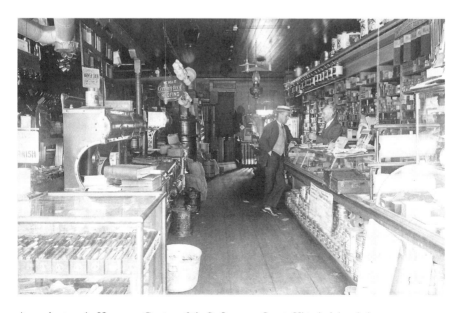

An early store in Hermon. *Courtesy of the St. Lawrence County Historical Association.*

trial, Smith and the Farnsworth sons were defended by Sawyer & Russell of Canton and E.B. White of Hermon. District attorney J.R. Brinkerhoff was the prosecutor for the people. W.H. Sawyer opened for the defense.

The *St. Lawrence Republican* of April 14, 1874, said:

His opening was not lengthy. He directed the attention of the jury to the improbability of the story told by Reed and dwelt upon the numerous contradictions in which the witness had involved himself on his cross-examination. He advised them that the defense would completely overwhelm every line of Reed's evidence, and that without that evidence, there was nothing left of the people's case. The subsequent examination of the witnesses for the defense completely established the truth of the assertion of the counsel.

When the defense was finished examining its witnesses, Sawyer asked Brinkerhoff whether he "felt that there was any evidence in the case

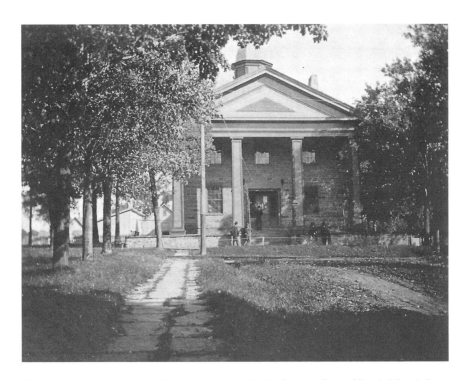

The old county courthouse in Canton. *Courtesy of the St. Lawrence County Historical Association.*

sufficient to entitle them to ask the Court that the case might go to the jury." Brinckerhoff conceded that his case rested almost entirely on Marshall Reed's testimony, which the defense had shot so many holes through that there was nothing left to work with. The paper said the case "was submitted to the jury, and they, without leaving their seats, declared the prisoners not guilty: and so ended the trial."

Although Almon Farnsworth's murder was never solved, at least his family was able to pick up the pieces and move on with their lives. It had been hard enough to lose a family member so suddenly; their sorrow was only exacerbated by the black cloud of suspicion that hung endlessly over the family. The media reported that the evidence presented in the case—or the lack thereof—clearly exonerated the Farnsworths and Halsey Smith. Theron remained in Hermon, marrying Fontella Healy later that year and starting a local newspaper called the *Hermon Union*. It had only been in print a few months when a fire swept through downtown Hermon in 1875, destroying the printing press. He and Fontella then moved to Camden, New York, where they cared for Mrs. Almon (Harriet) Farnsworth in her later years. Amos remained in Hermon; and another son and daughter eventually settled in Canton.

The conclusion of the sensational trial also allowed the good people of Hermon, who had been at odds with one another regarding the case, to set aside their differences and move on; for what transpired in the months following Almon Farnsworth's murder gave new meaning to the phrase, Divided We Fall. So much time and effort had been expended concentrating on just a few unfortunate suspects (even in the absence of credible testimony or evidence) that someone literally got away with murder. The *St. Lawrence Republican* put it well: "The unfortunate division in the public mind of the town where the crime was committed, and the conflicting theories formed and adopted by its leading citizens, have, for a time—if not forever—defeated the ends of justice and rendered all efforts thus far made to discover the real culprit or culprits."

THE UNFORTUNATE MURDER OF MARIA SHAY

OGDENSBURG, 1872

On Monday morning there died in this city a beautiful young woman, under circumstances which indicate that she was the victim of an attempt at abortion.
—*the* St. Lawrence Republican, *March 19, 1872*

The puzzling events surrounding Maria Shay's demise in 1872 prompted authorities to open a criminal investigation against Ogdensburg physicians, Peter Reid McMonagle and Evariste Mongeon. Mongeon was a young Canadian physician whose name was not yet recognized by most in St. Lawrence County. But McMonagle had made headlines two years earlier when he was indicted on charges of manslaughter in the abortion death of Mrs. June Hubbard of Ogdensburg. Due to lack of evidence or witnesses in the *People v. Peter R. McMonagle*, he was acquitted. McMonagle "was congratulated upon his deliverance," and a party was thrown for him. The *St. Lawrence Republican* said, "On Saturday evening, the Dr. arrived home, in this city, and was serenaded by his friends who employed the Oswegatchie Band for that purpose." Two years later, he found himself embroiled in another abortion-murder case.

Maria Shay was a resident of Morrisburg, New York, and had lived in Waddington for several years before a brief stay in Fagundus, Pennsylvania, in late 1871 where she went to live with her married sister—and apparently got herself into a bind. She returned to the area via the Rome Railroad on March 7, 1872—five months pregnant and single, but with enough cash on

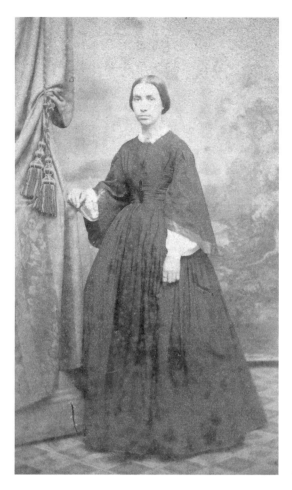

Courtesy of the author.

hand from sources unknown to remedy that quandary. In an article called "Another Abortion Murder in Ogdensburg," the *St. Lawrence Republican* said, "The unfortunate victim seems to have been supplied with money to bear her expenses while here." When Shay first arrived in Ogdensburg for the purported purpose of "producing a miscarriage," she went straight to the Baldwin House, as apparently instructed, and sent a note to Dr. McMonagle, letting him know she had arrived. He then called on Mrs. A. Allen to go to Miss Shay's room at the house and "have an interview" with her. After the interview, it was decided that Shay would go to Mrs. Allen's house the next day and remain there until the following Friday, a week later. Mrs. Allen lived over a store on the corner of River and Lake Streets. Dr. McMonagle visited the victim at the Allen residence on Friday, March 15, 1872, accepting

payment of five dollars for his part in introducing the victim to Dr. Mongeon, who was said to be "a suitable person to perform the operation." After that, McMonagle had nothing further to do with Miss Shay or the tragic events that unfolded, resulting in her untimely death.

One source said, "The abortionists have held high sway in [Ogdensburg] for some time past," and the actions of those few individuals had affected the public perception and reputation of all in the medical field in the Ogdensburg community at that time. "Dr. Furness," the article stated as an example, "was called upon to attend a young woman who arrived at one of our hotels the early part of the present week, who had been taken suddenly ill. It turned out upon inquiry that she was enceinte [pregnant], and had come here to place herself in the hands of an individual who has the reputation of an abortionist. Of course she was advised of the criminality of such a course and instructed to return to her home." Desperate out-of-towners in a delicate way often arrived at the train station alone, sent by family members to take care of such illicit matters. Sadly, due to the nature of the beast, some, like Miss Shay, never made it out of the city alive.

New York state had abortion laws in effect since 1830, when an attempt to induce abortion at any stage of pregnancy, by any means (i.e. drugs, instruments, etc.), was considered a misdemeanor punishable by up to a year in prison, and a successful abortion after quickening (when a woman first feels fetal movement) was considered to be second-degree manslaughter. The exception, in New York state, was if abortion was clearly necessary to save the life of the woman, as advised by two physicians. The 1830 laws were directed at the abortionists; however, in 1845, the law was amended to make the pregnant woman who knowingly submitted to an abortion guilty of a misdemeanor. And, in 1881, the law was further amended to make both the woman and the person performing the abortion guilty of manslaughter if an abortion was performed after the quickening, which generally occurs between fourteen and twenty-one weeks of pregnancy. It's likely that Maria Shay had already experienced quickening by the time she arrived in Ogdensburg to solicit an abortion.

After summoning a jury consisting of C.H. Butrick, Thomas C. Atcheson, Allan McTavish, C.B. Herriman, George Witherhead, and John McCarthy, Coroner J.R. Furness held a coroner's inquest. Somebody had a lot of explaining to do. While Mongeon and several female witnesses were questioned, McMonagle had left town before the *you-know-what* hit the fan. His absence left him open to unchallenged libel and slander from the other

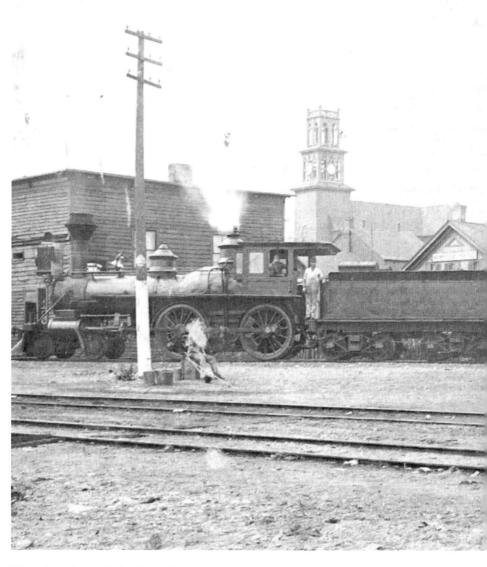

The train station at Ogdensburg. *Courtesy of the St. Lawrence County Historical Association.*

guilty parties. A shocking revelation marked the second day of the inquest, when it came to light that Shay must have been pregnant with twins, because the postmortem examination revealed the presence of a five-month-old fetus still inside of her; while, at least three witnesses called to the stand claimed that she had given birth in the street, and that they had examined the fetus.

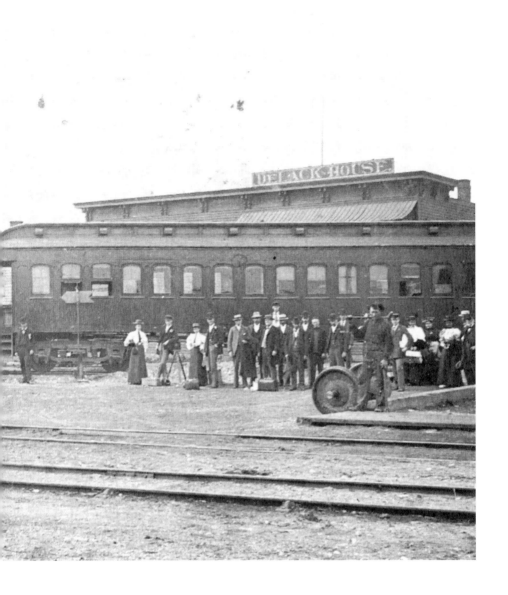

The *St. Lawrence Republican* of March 26, 1872, reported on the inquest, saying:

> *It's proper to say that the witnesses, Dr. Mongeon, Mrs. Allen, and Miss Fieldson, were positive in their testimony as to the fact that Miss Shay had given birth to a child as early as Thursday evening, March 14th. The women had examined it sufficiently to ascertain its sex. By Mongeon's testimony,*

this birth occurred between the post office and the bridge on Tuesday evening. It is proper to state that Mrs. Allen disputes this testimony. At the time of the post mortem [sic] examination, no evidence had been given about the birth of one child, and they had not considered the possibility of twins. On Wednesday, some of them thought it possible that there might have been twins, while others thought to the contrary.

In the evidence taken Tuesday and Wednesday, it was pretty clearly indicated that some kind of an operation had been performed upon Miss Shay for the purpose of producing miscarriage, by someone to whom she had paid $40 or $50. Dr. Mongeon testified Wednesday afternoon that on Sunday he sent for Dr. McMonagle, from whom he had received this patient, and that he declined to come, saying he had not time. It appears that Miss Shay paid $30 to Dr. Mongeon and $40 or $50 to some other party.

The coroner's inquest closed on Thursday morning, and based on the witnesses they were able to question, a verdict was reached as follows:

That Peter R. McMonagle of the city of Ogdensburg…did then and there feloniously and willfully use on and in the womb and body of the said Maria Shay…a certain instrument to the jury unknown, with intent then and there to cause the said child of the said Maria Shay to be forcibly delivered from the said womb. And so the jurors say that the said Maria Shay…became mortally wounded and distempered…and so the jurors say that he, the said Peter McMonagle, willfully and feloniously by the means and in the manner aforesaid…did kill and slay in the manner and form aforesaid.

And the jurors aforesaid further say that Evariste Mongeon, of the city of Ogdensburg…was feloniously present with certain instruments, drugs, medicines and things to the jurors unknown at the time of the killing and slaying aforesaid…and that he, the said Evariste Mongeon, did comfort, aid, assist, and abet the said Peter McMonagle in doing and committing the felony and manslaughter aforesaid against the peace of the people and this State and their dignity.

Upon reaching their verdict, Dr. Mongeon was taken directly into custody to be examined and questioned by the coroner, after which he was committed to jail to await trial a month later. The evidence against him was said to be indisputable, and it was further corroborated when the body of one of Miss Shay's fetuses was retrieved two weeks later.

The Unfortunate Murder of Maria Shay

According to the *Utica Daily Observer* of April 3, 1872:

> *The* Ogdensburg Advance *of Tuesday says: The body of the child of Miss Shay was fished out of the canal last Monday, and the following day, the coroner's jury were* [sic] *re-summoned, when the body was identified by Mrs. Allen and Dr. Mongeon as one of the victims of the late abortion. We would say that Dr. McMonagle disappeared just after the woman's death and has not been seen in this county since; hence, he has not yet been arrested. Report says he is in Brockville or Prescott, and is waiting to get his bail fixed to his satisfaction before he returns.*

Mongeon's trial, which commenced on April 24, 1872, yielded further details. After McMonagle left Mrs. Allen's apartment that Friday, Mongeon said, he told his anxious patient that he required a thirty-dollar payment from her prior to providing the unlawful service. The *St. Lawrence Republican* for the week of April 28, 1872, said, "Miss Shay paid the money, and the prisoner [Mongeon] commenced his fiendish work. The details of the transaction were given with painful minuteness by the two female witnesses; but they are unfit for publication." According to the article, Mongeon finished the job, delivering a stillborn infant the next day. "Upon the birth of the child, the prisoner took it, placed it in a cigar box, lashed a couple of bricks to it, and threw the box into the canal." By his own admission, the doctor was under the influence of alcohol at the time of the procedure. And, regardless of the popular opinion that he was a skilled physician, he was nevertheless a criminal. Miss Shay's state of health rapidly declined after the procedure, and she finally succumbed on Monday morning, after two days of unspeakable agony. The *St. Lawrence Republican* said, "The evidence of Doctors Sherman and Bartholomew went to show that the poor girl had been cruelly and foully dealt with, and that her death resulted from it." The female witnesses stated that Mongeon, realizing his folly, attempted to sway the witnesses with threats if they did not say what he told them to say about the death, in the event of his arrest; and they refused.

The jury needed just a short time to find Mongeon guilty only of "procuring or assisting to procure an abortion," for which the defendant was sentenced to five years at Dannemora. He was not charged with the murder of Miss Shay or her twins. Although many residents of Ogdensburg attempted to secure his early release, the general term of the supreme court

affirmed the conviction, and the court of appeals agreed that the conviction should be sustained and ruled in favor of the people.

Mongeon served out his time and was released on January 23, 1877. McMonagle was never charged for his role in the sordid incident. He moved to Prescott, Ontario—across the way—immediately after Miss Shay's death. He and his adult children then maintained respectable, upstanding positions in society on either side of the St. Lawrence River.

VAN DYKE'S DUBIOUS CONVICTION

OSWEGATCHIE, 1877

A mere boy, nineteen years of age, almost irresponsible by nature, training, and years, has been hanged; and there is an uneasy feeling in the county that perhaps the verdict was not just right.
—Ogdensburg Advance

In late May 1877, nineteen-year-old wanderer, Van Van Dyke, went to the Catharine Dailey homestead in Oswegatchie, about three or four miles south of Ogdensburg, in search of work. He was born in the town of Shelby in Orleans County on September 2, 1858. His father was, by all accounts, an abusive drunk who brought women home and had relations with them even as his wife and children were still living under the same roof. After some time, Van Dyke's mother, Mary, got the courage to leave the loveless marriage, took her children and moved in with a man named Lucius Chamberlain in Medina, New York. Hence, the young Van Dyke decided that marriage was not a big deal—that it didn't mean you were stuck with someone for the rest of your life. Look at what happened to his parents. It was a viewpoint that would lead him, years later, to enter into a less-than-ideal marital agreement that sealed his fate. With his parents embroiled in their own respective dramas, Van Dyke did as he pleased. But the *St. Lawrence Republican* of December 26, 1877, said that he "was ill-treated at home and abroad, kicked and cuffed wherever he was." At the age of fourteen, Van was sent to the Rochester House of Refuge after being implicated in a horse

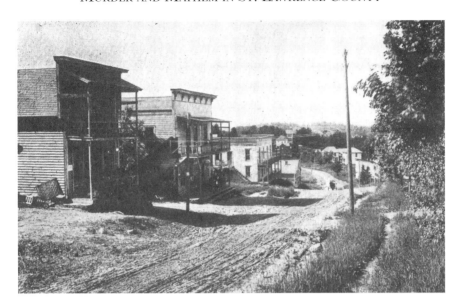

A dirt road leading to Oswegatchie. *Courtesy of the St. Lawrence County Historical Association.*

theft. He was pardoned and released six months later. He never committed another serious offense after that, but instead found employment in the circus, as a sailor, and finally as a farm laborer.

At the Dailey farm, it was agreed he would earn his board until haying time, at which time he would begin receiving wages. Little did the young man know that the deal he struck with these acquaintances would ultimately become his ruin. The Dailey household at the time consisted of Mrs. Dailey, a widow, and her two adult grandchildren, John and Mary Claffey. Mary Bartholomew was a pretty, young girl of nineteen who had been released from an orphanage earlier that year to go out into the world and earn her living. She was first placed with Mrs. Dailey's brother-in-law, James Dailey, but was passed back and forth between his family and the Claffeys at Mrs. Dailey's house, as needed. An *Ogdensburg Advance* article said Mary was "transferred from one family to the other as often as there was any hard work to be done at either place." Such was the life of released orphans, but the hard work was the least of the young woman's problems. According to the *Franklin Gazette* of December 28, 1877, the married "Claffey had seduced the girl," resulting in pregnancy. In early July 1877, Mary Bartholomew, single and four months pregnant, "commenced a bastardy [*sic*] suit against John Claffey." Mary had grown tired of being taken advantage of—not just by the

man who impregnated her, but by the two families that tossed her back and forth like a hot potato. Claffey had to pay his bail at Potsdam Junction, and then, to remedy the situation (or "get Claffey out of the scrape," as the paper said), he crafted a plan to appease his accuser with James Dailey and young Van Van Dyke. Van Dyke, it was decided, would marry Mary Bartholomew, and make it all proper.

So on July 24, 1877, Claffey, Van Dyke and Mary rode to Heuvelton where the latter two were married. Claffey and Van Dyke provided aliases for their surnames (Douglass and McNally, respectively), and the trio then returned to Mrs. Dailey's to live happily ever after—or so one might have

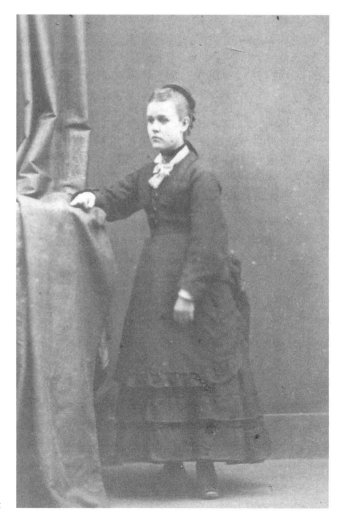

Courtesy of the author.

hoped. But you can't build a foundation on lies. It goes without saying that the wedded couple was not only young and naïve, but they didn't even know each other when they were convinced to marry by adults who should have known better. Now there were two victims trapped in an inescapable situation. On July 29, just five days after the hasty wedding, Van Dyke was standing in the woodshed with his gun raised when it discharged, whether intentionally or not, instantly killing his young, pregnant wife who was shot through the head as she stood in the kitchen.

The *Ogdensburg Advance* reported on the sensational crime, saying of Van Dyke:

> He ran out to the barn where Claffey and another fellow were at work, crying that he had shot his wife and that he did not know the gun was loaded, and for God's sake not to tell anybody, but to let him run away. Claffey persuaded him it would be best to give himself up. They came to Ogdensburg and Van Dyke gave himself up and was put in the lock up. The coroner's jury, after a three days' examination of the case, gave a verdict of willful and malicious murder. He was then sent to Canton jail, was indicted by the grand jury, and on October 30, his trial began and continued three days, concluding with a verdict of murder in the first degree. He was sentenced to be hanged Dec. 21.

But something about the whole sad case smelled fishy to a lot of people, so much so that vigorous efforts were made on Van Dyke's behalf to secure a reprieve by his counsel. However, the governor, in the end, felt the decision of the grand jury was just and refused to interfere in the impending execution. Yet all along, Van Dyke insisted he didn't deliberately shoot his wife that day. Of all the lies he had ever told—and there had reportedly been a few—he never once wavered in his assertion that the fatal shooting was an accident. He had fired the gun just a day or two before his wife's death and remembered putting it away unloaded, like always. He vehemently denied knowing that the gun was loaded before he picked it up that fateful day and "expressed and implied…that the gun was loaded by Claffey for some bad purpose." John Wells, who was with John Claffey at the time of the shooting, swore before the jury that after he heard a shot, Van Dyke came running out to the barn saying he had shot his wife and asked the two gentlemen to give him a couple of hours before telling anyone so that he could run away. The *Ogdensburg Advance* of October 1877 said, "Claffey asked him what he

pointed a gun at her for. Van Dyke said he did not know the gun was loaded and did not see any cap on the gun." Van Dyke later told the sheriff that Claffey said something on their way to Ogdensburg that made him wonder if perhaps Claffey had set him up—again; first in an impromptu marriage and now in this terrible alleged crime. He said Claffey told him that the gun did "just what he [Claffey] intended it should do." The words seemed to fall on deaf ears as the clock ticked surely away toward Van Dyke's doom. Indeed, the *Franklin Gazette* reported that statements made to the sheriff by Van Dyke on the eve before his execution were "too shocking for publication, and we sincerely hope he has been misrepresented." In other words, if what Van Dyke told the sheriff were true, they were about to hang the wrong man.

Van Dyke penned a final, farewell letter to his brother that was printed in the *St. Lawrence Republican*:

Mr. Peter Van Dyke and Mr. W. H. Chamberlain from your brother and friend Van Van Dyke Canton Jail farewell good buy.

Dear Brother I now take the opertunity to rite to you and the Doctors family this is the last words that I will eer speak to you and I wish that you wood doo won request that I ask of you and this is what I want to say is that you will stop drinking now for my sake and our Dear and aged mother that I leave behind mee on this earth Will you stop and live more like somebody You can see what I hav com to by not minding anything what people says to mee this is what I wanted to ask you to doo tell the Doctor that I wood like to see him and his family once more I have rote so much that I am getting tired of riting so I will close now I forgot to tell you that I am going home not guilty for the crime that I am going to bee hung for soon I hope the lord will have mercy on my sole when I am out of the world this is all I have got to say May I meat you on the other shore so now farwell for ever and ever This is from your Dear Brother Van to my Dear Brother and the Doctors and his family and Peter Van Dyke. [sic]

Van Dyke did "not seem to have shown any viciousness since he has been in confinement, but has been good natured and courteous to all who have visited him," according to the *Ogdensburg Advance*. But was he truly unaware the gun was loaded when he raised it to his shoulder, while puttering around in the wood shed that day? If so, the new revelations came too late in the

game to change the end result. At that point, the only people that could halt the execution weren't listening. The *St. Lawrence Republican* of December 26, 1877, said Van Dyke had "drawn up a statement covering several pages of foolscap, but the district attorney has not examined it, and refuses, at present, to make it public. We are, however, informed that it in no way confesses his guilt." It likely incriminated Claffey and perhaps others in a plot to frame Van Dyke in Bartholomew's murder; thus ridding their happy homestead on the Ridge of both of the nineteen-year-olds (and of Claffey's illegitimate unborn child). Van Dyke's statement never reached the public eye, but it must have made district attorney J.R. Brinkerhoff second-guess, even for just a moment, the irreversible penalty the young man was about to pay with his life. Records from the St. Lawrence County Historical Society's crime archives say that, just as Van Dyke was about to be hanged, Brinkerhoff asked Sheriff Wheeler, "Do you really think this man is guilty?" He had every reason not to make the prisoner's statement public. It wouldn't have looked good for his case, if the decision was suddenly overturned the day before the execution when the statement was provided to him; and the public would have been outraged if it were learned too late that the mysterious statement exonerated Van Dyke. It's no wonder the community had a sinking feeling that an innocent man was about to be sent to the gallows.

The gallows, which had been used to hang four other murderers from around the state, "were erected in the jail yard in plain view of Van Dyke's quarters, and he was often seen to view them with a good deal of curiosity." Friday morning, the day of the execution, Van Dyke ate a small piece of toast and smoked a couple of cigars. He asked to see the members of Sheriff Wheeler's family who had treated him fairly and with the kindness not often afforded one in his position.

The *St. Lawrence Republican* described the day of the execution as such:

> *In the forenoon Van Dyke said he did not like to be sent home in the old, shabby clothes he had on. A short time later, his measure was taken, and a very neat-looking suit of clothes was brought for him. At 12 o'clock the sheriff's family bade him goodbye, one of the young ladies pinning a pretty button-hole bouquet on the lapel of his coat. They all left the room broken down with feeling, while Van Dyke was very much distressed and showed much emotion. Soon afterwards, the jury…took their seats on the platform* [that had been] *prepared for them.*

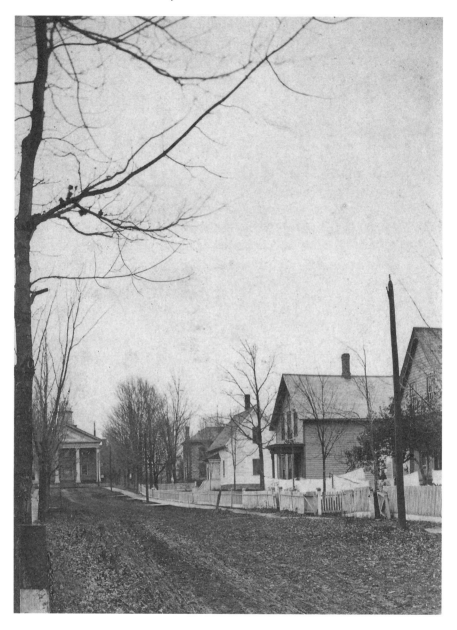

A dirt road leading to the old county courthouse in 1877. The original jail where Van Van Dyke and others in this book were imprisoned is barely visible to the right of the courthouse in this image. *Courtesy of the St. Lawrence County Historical Association.*

At 12:30 Sheriff Wheeler entered, followed by Van Dyke between deputies Tanner and Conkey. He was led under the gallows and walked with a firm step, yet with a half-terrified expression on his countenance. Van Dyke stood alone, clasping the hand of Rev. Mr. Gardner and listened attentively while his death sentence was read by sheriff Wheeler…It was noticeable that, while Rev. Mr. Gardner's hand, which clasped Van Dyke's, trembled and shook violently, the prisoner's was firm and without a quiver. The sheriff then asked if he had anything to say. He replied in a firm, clear voice, "Yes, I want to say a word to all of you, old and young, and that is to beware of bad company and liquor. You don't know what a bad thing liquor is—it will put you into trouble and get you here. Bad company has ruined me and brought ruin upon many men. I am not guilty, and I am not afraid to meet my God this afternoon." After he concluded, Rev. Mr. Gardner read some appropriate passages from the Scriptures and made a very fervent prayer. After this, the arms and legs were pinioned, the rope put around his neck, and the black cap shut out the world forever from his sight. In an instant, at 12:42, a slight rasping sound was heard as the rope which held the weight was severed; there was a rustle and a dull thud and Van Dyke's body shot up into the air, the knot shifting under the chin, bending his head back as he fell. He was quiet for a moment, and then the fact that his neck was not broken and that he must suffocate was fearfully apparent. For three or four minutes, the body was terribly convulsed, and the efforts he made to get breath were horrible to behold, and a loud wheezing sound was heard by all present.

Finally, at 12:57, fifteen minutes after the rope had been cut, young Van Van Dyke was pronounced dead. Twenty-four minutes later, his body was taken down and placed directly into a plain coffin for viewing. The face, by that point, was hardly recognizable, as one can imagine. The well-used Bible that Rev. Mr. Gardner had given him was placed on his chest; the casket was closed; and the remains were then sent to Medina, New York, to his mother's common-law husband, Lucius Chamberlain. As for his mother, who attempted to pass herself off as a good Christian, her lack of emotion regarding her eldest son's sad plight offers some insight into the loveless life she provided him. She told the sheriff, whose family had befriended the young man during his incarceration, "it might as well be a verdict of death first as last, for if [Van] escaped this time, [I] would have the same thing to go through again." But the media spoke increasingly well

of the unfortunate young man after his passing. The *St. Lawrence Republic*, for example, offered this final thought in their lengthy, post-execution story: "The animal courage which Van Dyke displayed was the marvel of everyone." Had he willfully and maliciously murdered his new bride, as the grand jury decided? We'll never know. If the jury was wrong, and it was truly a freak accident, then there were two unfortunate victims in this sorry tale.

FRANK CONROY, WIFE SLASHER

OGDENSBURG, 1896

The bloodiest crime that ever stained St. Lawrence County was enacted in Ogdensburg last Wednesday morning when a laboring man and an athlete, aroused to a fiendish state…deliberately murdered his wife by cutting and slashing her in a most appalling manner with a large butcher knife.
—Courier & Freeman, *May 27, 1896*

In 1896, Frank Conroy was a forty-two-year-old, uneducated longshoreman and day laborer who had served with the 12th United States Cavalry and fought at Wounded Knee. He met his wife, Kate Grant, in Kingston, Ontario, when he joined Battery D of the British forces at Frontenac barracks. She was working for the Salvation Army. When the ill-fated couple married in 1887, Kate was just seventeen, and Frank was thirty-three. A few years later, they moved to Ogdensburg and were blessed with two daughters; but Conroy often returned to Montreal without his family for extended stays, whenever employment opportunities arose. It was during one of these jaunts that he would later claim he heard rumors of Kate's infidelities back in Ogdensburg.

According to the *Northeastern Reporter* (vol. 47), which detailed decisions of the Court of Appeals of New York in 1897, Conroy asked Ogdensburg acquaintances to keep an eye on his beautiful, young wife in his absence and report any inappropriate behavior to him. Because Kate was unaware of this directive, she became alarmed when unknown men seemed to be stalking her. One guy even camped out on her doorstep, according to her

friend's later testimony. This prompted Kate to keep two butcher knives handy for protection. She could never have imagined they would one day be used against her. She was also fearful for her children's lives. So in the month of March 1896, with a heavy heart, Kate Conroy placed her children in the Roman Catholic Protectory until her husband's return. A protectory is an institution that provides food, shelter, religious instruction and education, primarily to neglected and abandoned children. At least there, her two young daughters, ages five and seven, would be safe—and they wouldn't have to witness their mother's impending doom.

On Saturday night, May 16, 1896, Frank Conroy made a surprise trip home from Montreal, arriving around 10 p.m. He had told a friend that he intended to one day catch his wife in the act of being untrue to him. Never mind that he admittedly boarded with two women of ill repute in Montreal each time he went back on "business." Kate was not home when he arrived; but her so-called friend, Mrs. Fleming, allegedly told Conroy that she had gone out riding that day with an unidentified man. Conroy was understandably distressed and grew increasingly angrier when his wife failed to return home that night. It wasn't until around 9:30 p.m. the following evening that she finally showed up and told her husband she had been visiting a friend, not riding with the man in question. Conroy checked this story out with the other so-called friend the following morning and was told that his wife had not visited her since the previous week. Based on the postmortem examination and witnesses who heard Kate telling her husband to stop kicking and choking her, we can assume Conroy beat Kate from the time he found out she lied to him until the moment he killed her, even though he denied this. The *Reporter* said, "The autopsy revealed some dozen or more black and blue spots on different parts of the person of deceased, and as many more abrasions, in addition to the knife wounds, which will be referred to later. There was some other proof offered by the people as to the ill treatment of the deceased by the defendant between Sunday night and the fatal Wednesday, but it is unnecessary to go over it in detail."

Around town, Conroy was considered to be a man of limited intelligence. He was fairly well known for his athletic prowess, winning many trophies at various sporting events like boxing. No wonder—he practiced regularly on his wife's face. On May 20, 1896, he snapped. After three days of constant arguing and trying to convince Kate to move far away with him and start over—away from the immoral temptations he believed she had fallen victim to in Ogdensburg—Conroy finally realized she wasn't going to leave with

him. She had developed her own strong, self-reliant personality in his many absences, and she clearly didn't wish to remain married to him any longer. Indeed, the young girl he married had finally grown up and become her own person, not his punching bag. For that, she would pay the ultimate price. Realizing his marriage was finished, he decided that if he couldn't have her, nobody would. A close friend named Charles St. Andrews would later tell the jury that before Kate returned to their dwelling on Sunday, he had a strange conversation with Conroy. Conroy had said, "Can I kill them both if they come here?" When St. Andrews asked who he was talking about, he said, "My wife." His friend suggested that he ask a police officer named Tuck for some advice. When Tuck was called to the stand, he said Conroy had asked him if he would hide in the apartment and arrest his wife and her supposed companion if they arrived there. Tuck said he couldn't do such a thing, but that he could "proceed against the man for alienating the affections of his wife." Conroy went from one individual to the next, hoping in vain to find someone sympathetic to his cause that would tell him he could do whatever he wished to his wife, even if that meant killing her, and he wouldn't get in trouble for it. Of course, nobody was going to say such a thing. After visiting the mayor's office and finding the official he sought not in, he was told to talk to the city recorder, Mr. Houston.

According to the *Northeastern Reporter*, the recorder's testimony was as follows:

> He stated, "Mr. Houston, I am in serious trouble, and it is about my wife. I heard there is a certain man in Ogdensburg [who] has been making his brags that he had immoral relations with my wife. Now, my God, Mr. Houston, isn't that awful for a married man with two children? It is nearly driving me crazy. I want to find out if this is true and what I can do to those men." Mr. Houston sought to calm him, and the defendant replied, among other things, "My God, I could murder that woman if I thought it was true." After the defendant grew calmer, he told the recorder he wished to take his wife away from Ogdensburg and her evil associations and he thought three certain men he named ought to pay $26 each towards raising the money necessary to defray the expenses of his removal to another locality. It was arranged that the recorder was to address letters to these men at once, making this suggestion, and defendant was to return the next morning at 10 o'clock to ascertain the result.

When Conroy asked if it would be a good idea for him to force his wife to remain home until the next morning, the recorder said, "I don't know but what that might be a good plan [*sic*]. But don't have any unpleasantness; don't have any trouble with her." Conroy replied, feigning earnestness, "I will not misuse her in any manner, and I will be here at ten o'clock tomorrow." His promise not to misuse her was the ultimate lie, and his appointment the next morning would never be kept. Less than an hour—*an hour*—after Conroy left the recorder's office, he cornered his wife with a butcher knife. The rest is history.

About half-past eleven on that fateful morning, Kate had just arisen and had not even eaten breakfast yet when Conroy returned from his visit with the recorder. She was wearing only a thin calico wrapper over her underclothing when he walked in, and her hair was still in braids as she stood in the kitchen preparing to wash up. "Her corset and part of a street dress lay on a table opposite her bedroom door," according to the *St. Lawrence Republican* of May 27, 1896. The moment she saw Conroy coming up from behind her at the sink, Kate must have seen the darkest evil in his eyes. She grabbed one of the butcher knives, brandishing it to fend him off. But in the blink of an eye, Conroy grabbed the knife from her hand and turned it on her; and as she grabbed at it to keep it from stabbing her, it sliced through her fingers, causing blood to gush down her forearms. Conroy had crossed the line and nothing was going to stop him now.

Several tenants of the same building hurried to the scene when they heard Kate scream for help. The *St. Lawrence Republican* said that Edward Day was visiting tenant Minnie Derby when a woman ran to Mrs. Derby's apartment saying that Mrs. Conroy needed help. Day went down to the Conroy apartment and found the door open, and Constable Joseph Lyzotte was approaching from across the street with every intention of diffusing the volatile domestic incident. The two men, along with Minnie Derby, stood in the Conroy doorway and could see Frank Conroy standing inside with a knife in his hand, blocking the door to the kitchen so that his unarmed wife couldn't escape. Mrs. Derbie heard Kate saying, "Frank, look what you have done to my hands." As she pled for her life to be spared, Frank coldly said, "Go wash your hands." Day, the article said, heard Kate say, "For God's sake do not let him kill me! Oh, my children!" To that, her husband hissed, "You have been going with everybody, and I have got tired of it." Then he told Lyzotte and the others to get out. For reasons I'm sure the constable regretted for the rest of his life, he complied, turning his back on the situation, and

walking away—even as the screams of the victim rang out. The court of appeals, in its decision later, wrote, "It seems strange that the outsiders did not interfere at this point, but defendant was allowed to close the street door, and the tragedy then in course of enactment proceeded."

Kate Conroy suffered the most gory, merciless fate imaginable. It was estimated that there were 289 blood spots in the kitchen, leading from the sink and then around the table, and 385 distinct blood spots on the floor and walls of the front room, closest to the street, where she succumbed. Her last words, according to Mrs. Fex, whose husband owned the new apartment building in which the murder occurred, as well as the adjoining meat market, were, "Murder! Spare me for my children! For God's sake don't murder me! You are bound to murder me. Oh, Lord, have mercy on my soul. Mother!" Seconds later, a sickening silence replaced the mayhem, and Conroy opened the door and announced calmly to nobody in particular, "You can come in now. I have killed her." When asked why, he said, "I killed her because I loved her, and she had been untrue to me." As the constable walked him to the city lock-up, Conroy asked that he have Father Conroy, an unrelated priest, pay him a visit in jail and that the constable provide him with the next day's paper, so he could read whatever was written about him.

Dr. Stillwell was immediately summoned and found the nearly exsanguinated victim lying inside the door in a pool of blood. She had no discernable pulse but was still breathing, though barely. Three or four minutes after Stillwell arrived, Kate Conroy was dead. A coroner's inquest was held at the scene by Coroner Smith of Winthrop at 8 p.m. that evening. By then, an estimated 1,000 people had surrounded the building. Several doctors assisted Dr. E.H. Bridges and Dr. G.C. Madill during the postmortem examination. The *St. Lawrence Republican* of May 27, 1896, reported, "The perfection of physical health of the woman was a source of wonder to the physicians. Her brain weighed 51 ounces, two or three ounces heavier than the average female brain. She was 5 feet 7 inches in height and weighed about 145 pounds."

The paper, as Conroy had hoped, offered a comprehensive report on the murder the next day, with Dr. Bridges detailing the scene as such:

> *It was while standing at the sink that the brute assailed her and her desperate battle commenced. Blood stains lead from the sink to the table in the kitchen and circle the table, and it is evident that the bleeding, screaming woman ran around it endeavoring to escape the fury of the beast in whose power she found herself.*

Frank Conroy in the St. Lawrence County lockup. *From the* St. Lawrence Republican, *May 27, 1896.*

She finally fought her way to the hall; and, there, was finished in front of the door leading to the street...Beside the body of the woman, which lay with the head toward the door, with the loose wrapper saturated with blood wound around her neck, was a pool of blood about three feet in diameter... On the table in the kitchen lay the knife with which the butchery was done. The blade is twelve inches in length and about 1-1/2 inches in width and curves backward like a scimitar. The blade is bent to one side by its being wrenched from the woman's hands...There were black and blue spots and wounds on the body to the number of 25 or 30.

There was a small wound in the chest two inches above the end of the sternum which extended to the bone. There were several cut wounds on the inside of the hand on the palms and fingers. One finger was cut into the joint. There were abrasions on the arms and a gaping cut wound 3 or 4 inches in length on the inside of the upper arm.

On the left side of the face, a flap was raised from the cheek about 1-1/2 inches wide and the cut extended over the eye nearly to the center of

the nasal bone. The cut reached to the bone. A little above and back of the ear within the margin of the hair was a cut two or three inches in length, cut to the skull.

The probably fatal wound was in the left side of the throat one-half inch back from the angle of the jaw and extending parallel with the jaw. The wound was gaping and was two inches in length. It extended backward into the back part of the throat and nearly severed the epiglottis and severed the exterior jugular vein and the exterior carotid artery.

Dr. Bridges said that he was of the opinion that the woman died of hemorrhages. The body was nearly exsanguious.

The jury for the coroner's inquest found that Kate Conroy "came upon her death from a wound or wounds upon her throat, face, and body inflicted by a large knife; that said wounds were inflicted by Frank Conroy with the premeditated and deliberate design to effect the death of the said Kate Conroy at the city of Ogdensburg on the 20th day of May, 1896." Conroy was arraigned before Recorder Houston on a first-degree murder charge and

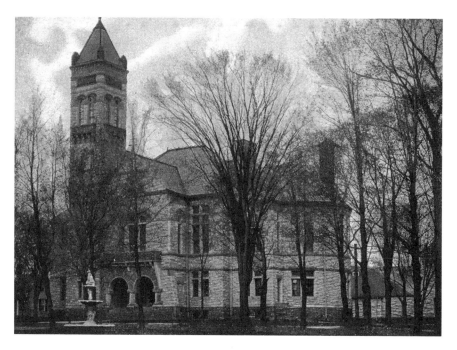

The St. Lawrence County Courthouse, where Frank Conroy's trial took place. *Courtesy of the St. Lawrence County Historical Association.*

was taken to Canton by police officer Sova to await grand jury action. The *Norwood News* of June 15, 1897, said Conroy was tried before Justice Leslie W. Russell in Canton the first week of August and found guilty on August 10, 1896. He was sentenced to be electrocuted at Dannemora. Although an appeal was taken to the Court of Appeals of New York, the judgment of conviction was affirmed, and the lower court was directed to carry out the sentence. Thus, on August 10, 1897, "the Ogdensburg wife murderer was successfully executed at Clinton Prison" in Dannemora, as reported by the *New York Times*.

THE PLOT TO POISON JOSEPH KIPP

CLIFTON, 1904

It is a simple, homely story of an old man addicted to drink, a younger wife, an alleged paramour in the person of Burrell, a son of not too strong a mind, alleged crude scheme for poisoning, the use of the son as a tool, a failure of the poison to work until the old man—by his repeated cries—has done much to expose things, arrests, weak knees, confessions, and the outcropping of evidence.
—St. Lawrence Weekly Democrat, *December 15, 1904*

Joseph Kipp couldn't win. In July 1903, he and his wife of twenty-seven years, Carrie, had separated, and he moved into the soldiers' home in Bath for nine months. While he was gone, Carrie, who had married him at fourteen (unaware that he never divorced his first wife), became romantically involved with John Burrell, a longtime friend of the family and a Benson Mines saloonkeeper for whom she and her daughter worked. At forty-four, Burrell was only a few years older than Carrie. Her allegedly abusive husband's unexpected return to town presented a quandary for her—but nothing that the perfect crime couldn't fix.

When Joseph Kipp was found lying unconscious by the side of the road on April 15, 1904, he foiled Carrie Kipp's plan. He survived; at least long enough to point the finger at his killer who happened to be his very own son. He told anyone who would listen that Levi Kipp, with whom he'd been drinking when he passed out on the road, had put carbolic acid into his whiskey flask in an attempt to kill him. Levi was brought in for questioning.

A row of homes in Benson Mines. *Courtesy of the St. Lawrence County Historical Association.*

But when district attorney Ferris visited Benson Mines where the attempted murder allegedly occurred, he learned that Joseph Kipp had a history of threatening to take his *own* life by poisoning. Therefore, it seemed conceivable that the old man had tried and failed once again—and that, for some reason, he wanted to blame his son; so Levi was released.

The senior Kipp subsequently died two weeks later as a result of the poisoning incident, and Levi was again arrested following the coroner's inquest. He was taken to the St. Lawrence County Jail in Canton to await grand jury action. Carrie Kipp visited her son in jail to beg him not to tell on her; and if he did feel the need to squeal, she asked him to blame it all on Burrell, Levi later testified. There's not a lot to do but think and sulk when one is incarcerated, I imagine; and the thought of his mother and Burrell being free and having a good old time—while he sat rotting in jail—surely ate at him day and night. Finally, he decided that if he was going down, he wasn't going alone. After all, his own mother didn't seem concerned about him, so why should he worry about her? The *Massena Observer* of July 7, 1904, announced, "A new and sensational turn has been taken in the Kipp murder case by the confession of Levi Kipp…Young Kipp has made a confession implicating his mother, Mrs. Carrie Kipp, and her lover, William Burrell, a Benson Mines saloonkeeper, and alleging that they hired him to poison the elder Kipp."

With that, the local papers went crazy. Carrie Kipp and Burrell were taken into custody by sheriff's deputies N.M. Hyland and H.M. Farmer and

arrested on warrants charging them with murder in the first degree. While the move may have caught Mrs. Kipp and Burrell unawares, it came as no big surprise to a lot of folks.

The *Massena Observer* said:

> *At the time of the youth's arrest, it was believed by many that the authorities entertained the theory that the suspect was merely an accomplice, and that he was being held with the hope that close confinement would result in his telling what he knew of the case and possibly admit who was to blame for the mysterious death of the Benson Mines man. Young Kipp went before County Judge Hale Tuesday and made the confession in which he lays bare the plot by which he says he was hired by his mother and her lover…The youth's confession is said to be corroborated in many respects.*

Now that the cat was out of the bag, perhaps they would get some real answers to the case, barring any further unseen circumstances. Carrie Kipp, meanwhile, was getting a taste of confinement that didn't agree with her. The Canton *Commercial Advertiser* reported on July 21, 1904, that she "had a very bad sinking spell on Sunday" and that for a time, "it was thought she could not survive, but later in the day she was relieved and has improved rapidly." It went on:

> *Had she died, it would have removed one of the actors in a very puzzling problem that is now perplexing the brain of County Judge Hale, who is very anxious that no mistake is made in the disposition of the Kipp-Burrell phase of the case. If there is corroboration of the confession of Levi Kipp, the way is clear to send the alleged guilty twain to the grand jury, but there is at present some doubt as to whether there is responsible corroboration. As for Levi Kipp, he must be dealt with. He appears to be a criminal of the degenerate sort. A man who can be hired to assassinate his father is of the same stamp as a man who will accuse his mother of murder to save his own life.*

On July 19, Levi testified that on the day of the poisoning, he had gone to Harrisville to drink with his father; and the two continued their day of drinking at Mullen's saloon back in Benson Mines. He then returned home for dinner and begged his mother to take his father back. She refused, so Levi left. As he walked down the road, he said he met Burrell who walked

a ways with him. According to the *Massena Observer* of July 21, 1904, Levi said Burrell "told him it would be a good thing if his father were out of the way, and told him if he would give his father something out of a bottle his mother had prepared, he would give Levi $500." Five hundred dollars would be the equivalent of about $12,000 today, and Levi said he gave it serious consideration. He had never cared for his old man anyway. He then returned to his mother, and she upped the ante, telling her son that if he "would give his father a drink out of her bottle, she would give him her house and lot and most of the furniture." A house, property, furniture and a large wad of cash would surely give Levi and his young wife, Jessie, a good start in life, he must have thought. His mother, he later testified, handed him a dollar (now worth twenty-four dollars) and a half-pint bottle that was half full of a reddish liquid that turned out to be concentrated lye. She told him to take his father—her husband—to Star Lake and give him some of the poison when he was drunk enough not to realize what was happening.

In testimony at the trial of John Burrell, Levi said:

> *I then joined father on the road to Star Lake. I had the bottle with me. We passed Woodside's and Burrell's places and Martel's house. Fred Morrison drove by us with a three-seated open wagon. There were two persons with him. After Morrison passed us, father fell down by the road. Fred Morrison passed us again on his way back to the Mines. When he had gotten by a little way, I gave father a drink out of the bottle Mother had given me. Father took two swallows and handed the bottle back to me. I put in the cork and threw the bottle away. Then I called to Morrison to give me a ride home. We stopped at Burrell's saloon, and I bought drinks for both of us.*

The next day, Joseph Kipp was awakened by the cold and made it back to the meat market in town, where the poor master, Jake Lawrence, received him. Lawrence called Dr. Wiltsie to come to the aid of the ailing man who had been vomiting; and Lawrence set Kipp's soiled coat aside. The coat would eventually be brought in as evidence.

Per the *Massena Observer* of December 22, 1904, the physician testified regarding Kipp's demise as follows:

> *Joseph was in bed when he was called, and his clothes were mussed and his hair matted with dirt in it. His nose was skinned, his lower lip cut, and the chin was discolored, brown, with a burned appearance. The mucous*

The road to Benson Mines. *Courtesy of the St. Lawrence County Historical Association.*

membrane of the lips, mouth, and throat was burned. He complained very much, and his pulse was rapid. The doctor gave him a mouth wash of boric acid and prescribed liquid food of milk and eggs. He could not swallow. He visited him at least once a day till the night of April 27, when Kipp died. He saw him spit mucous membranes. The doctor fed him artificially and thought the old man better the third day after taking the poison. He thought the burning was done by carbolic acid but had never smelt the odor. Joseph told him that Levi gave the liquid to him.

Joseph Kipp suffered a horrible fate. He endured a slow, excruciating death at the hands of his estranged wife, his own son and perhaps a third party. But before he completely lost the ability to open his severely burned and ulcerated mouth and speak, he gave a deathbed deposition that was admitted in court at the trial of John Burrell. The *Massena Observer* said, "The testimony of the old man was taken at the bedside, with considerable difficulty, in an hour and a half."

It read as follows:

Levi had a letter to deliver at Star Lake. I started with him about 3 p.m. When about a mile and a half out on the road, he took a bottle from his pocket and gave me a drink from it. After taking a drink, I said to Levi, "It

burns. My God! What have you given me?" He said I wouldn't mind it in a few minutes. Levi left me, and I went to sleep, and when I woke it was the next morning, and I was all covered with snow. I tried to get up three times, and when I finally did, I went to "Jake" Lawrence's. I think the liquor that burned my lips, mouth, and stomach was carbolic acid, or smelled like it.

I was married once before the last time and never got a divorce from the woman. By my last wife, I had five children, Bertha, Levi, Emma, Anna, Willie and Minnie, who is now dead. I was put in jail once in Watertown for being drunk and have sometimes been drunk for three weeks at a time. Levi and I had been drinking and treating often at Lawrence's saloon before leaving for [Star] Lake. Once, about seven years ago, I fixed me up a bottle of poison just to scare the women folks about me taking it. Once when I had my toe cut off, I had carbolic acid put on it. I said I would take it, I was in such pain. My daughter Bertha took the bottle from me.

A young girl named Mary Martell testified that she had discovered the half-empty bottle of lye that Levi had thrown in the bushes; she gave it to her brother who gave it to the saloonkeeper, who gave it to Mr. Crapser—who gave it to Professor Henry Priest of St. Lawrence University! Professor Priest swore under questioning that the well-traveled bottle contained 40 percent alcohol and 25 percent concentrated lye. Priest also examined Kipp's stomach and found that it contained precisely the same "kind of matter as he found in the bottle," as did the vomit on the victim's coat. So the manner of death was certain; all that remained to determine was how much guilt each of the parties involved in the plot to kill Joseph Kipp had assumed. Initially, Burrell was released from jail, as it seemed Mrs. Kipp and Levi bore the brunt of responsibility, and Burrell was merely caught in the highly dysfunctional Kipp family drama. Carrie and Levi Kipp remained imprisoned. They say the apple doesn't fall far from the tree, and that certainly seemed to be the case in the Kipp family. Like her son, Carrie Kipp lasted just two weeks in jail before cracking and turning against Burrell. The *Massena Observer* of August 11, 1904, ran an article called "Mrs. Carrie Kipp Confesses Crime, Implicates Her Paramour, John Burrell."

It said:

Carrie Kipp…has been brooding over her crime of being implicated in the murder of her husband, Joseph Kipp, and last Thursday decided that she could no longer bear the burden of her mind alone, and called for the

officers of the law and confessed her crime in detail. It is probable that she could no longer bear to stay in jail and realized that John Burrell was free and celebrating. Shortly after the discharge of Burrell, Mrs. Kipp's daughter Bertha visited the jail from Benson Mines and informed her mother of the high banded celebration indulged in by Burrell. Presumably this, coupled with the sting of a guilty conscience, worked to unseal the lips of Carrie Kipp.

Armed with the signed confession of Mrs. Kipp and a statement by Bertha Kipp saying she had seen the bottle of poison in Burrell's possession and heard him speak of the crime, another warrant was issued for Burrell's arrest. He took "his old seat" in the county jail; and all three—mother, son and lover—awaited their December trial, having been jointly indicted for first-degree murder. Burrell's attorney, N.F. Breen, demanded for his client a separate trial, which was granted; and Levi and Carrie Kipp, who had no means to pay for an attorney, were assigned George H. Bowers and John R. Keeler to defend them. Their trial would follow Burrell's, and it would be the first time in St. Lawrence County history, according to the *St. Lawrence Weekly Democrat*, that "a triple-headed murder trial [had] taken place."

At Burrell's trial, Levi Kipp admitted to the defense that, when he returned to Benson Mines and went to Burrell's saloon after poisoning his father and leaving him for dead, he didn't tell Burrell the deed was done. Furthermore, he never asked Burrell for the $500 he had been promised, even after his arrest, which would have helped pay for a lawyer. Burrell's attorney, Mr. Breen, was quick to clarify those important points.

Breen said to Kipp:

You never went to Burrell and told him that you had done his bidding; you were arrested and were entirely without money to pay your counsel, and yet you never said one word to John Burrell about helping you. You knew that your mother was mortgaging her place to Burrell to raise money to pay for your lawyer, and you never sought Burrell and demanded the money; and yet you want this jury to believe that John Burrell agreed to give you $500 to kill your father?

When the trial continued the next morning, Levi Kipp further implicated himself by admitting that he had no problem killing his own father, because he had seen too much abuse toward his mother and siblings. Sometimes his

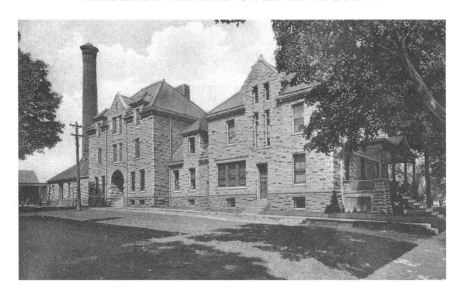

St. Lawrence County Jail, where Carrie and Levi Kipp were housed. *Courtesy of the St. Lawrence County Historical Association.*

father would come home drunk and kick the entire family outdoors for the night or wield a knife in his mother's face and beat her. He told the jury: "It did not trouble me at the dance that my father was lying in Jake Lawrence's saloon poisoned…My conscience did not prick me at all." Needless to say, those words sealed his fate and got Burrell off the hook.

Carrie Kipp, with her dark complexion and coal-black hair, arrived in court dressed from head to toe in traditional mourning garb—a black dress and a black bow in her hair. She appeared to be very respectable, somber and serious and answered all questions directed at her with a "calm, soft voice," that was barely audible. Her testimony added further mystery to an already baffling trial.

According to the *Massena Observer* of December 29, 1904, regarding Joseph Kipp's return and his demise, Carrie Kipp offered yet another version of the events, beginning with how she got the poison. She told the jury that she got the "stuff" in March.

According to her testimony:

> *After the little girl had gone to the store across the road, Levi went to Carlin's store and got it for her. She had used it before when she worked out and for herself for the time of her housekeeping. There was some of it in sight*

when Burrell came. He said, "The old man is back." She told him that she would try to live with him once more, and Burrell was mad and said, "After all I have done for you?" He [Burrell] had a bottle of whiskey with him and went to the sink and put some of the potash in the bottle and was shaking it when Bertha came in. He told her [Mrs. Kipp] that he had fixed it up with Levi and that he would give Levi $500 and for her to offer him the house and lot and furniture for him to give the old man a drink from the bottle…I asked what was in it, and he said, "You saw me put it in." I said, will it hurt him, and he said, "Don't fret; if the old devil gets a drink of that he'll sleep a while."

Mrs. Kipp ruined her credibility when she admitted to telling previous falsehoods regarding the incident, and she claimed to have been intimate with Burrell for a number of years, saying that Joseph Kipp was aware of the relationship. Burrell testified that he had a long, fairly complicated history with the Kipp family. After his wife died twenty-three years earlier, he began boarding at various places, including occasionally at the Kipp residence. He had purchased a lot from the Kipps on which he built a store, and he had helped Joseph Kipp out with money on several occasions. After Burrell moved out of the Kipp home three years earlier, Joseph Kipp had asked him to return; but Burrell declined. Carrie Kipp, he admitted, was paid by him to do his wash and clean his saloon. And her daughter, Bertha, played the organ in the saloon until midnight for $1.50 each night. Nobody would argue that Burrell and the Kipps had a codependent relationship, and according to everyone except Burrell, he and Carrie had also been romantically involved for a number of years. Yet the jury found Burrell to be more credible and his testimony more convincing than that of any of the Kipps.

Thus, after four hours of deliberation in the John Burrell murder trial, the jury returned a verdict of not guilty. Burrell was immediately discharged. His acquittal, according to the *St. Lawrence Republican* of January 4, 1905, was "due to the refusal of the twelve men who comprised [the jury] to believe the evidence produced against him." The article stated that the only damning evidence the prosecution provided was the testimony of the Kipps, who were "shown to be people of bad character."

On the other hand, the character borne by Burrell previous to this affair was pronounced by all witnesses to have been good. It would appear from the testimony and the verdict that Burrell had associated with a family of evil

habits and ill repute and that when trouble overtook them, they turned to him first for financial assistance, and then combined to make him bear the brunt of the punishment for the crime.

Consequently, Carrie and Levi Kipp pleaded guilty to manslaughter in the first degree for which Carrie Kipp was sentenced to twelve years and Levi Kipp to ten; thus ending another of St. Lawrence County's sensational murder trials.

JEALOUS JOHN HALL'S VIOLENT END

STOCKHOLM, 1905

Stricken Family Visited by Fire, Murder, and Suicide Within the Space of a Week—a Sad Wedding. A Jealous Brother's Vindictive Temper the Cause of the Crime, One of the Most Terrible in the History of St. Lawrence County.
—St. Lawrence Republican, *April 5, 1905*

When a mysterious fire destroyed the small home of Civil War veteran Nelson F. Hall the last week of March 1905, he and his two grown children lost what few possessions they had and were forced to move into an abandoned shack nearby for shelter until they could rebuild. But if they thought things couldn't get any worse, they were dead wrong.

Nelson Hall was a widower in his mid-seventies whose home was located on the Sand Plains near the small farming community of Buckton, two miles south of Stockholm Center. His beautiful daughter, Callie, was twenty-five, and his son, John, was thirty-two. Although they lived by modest means, Nelson and Callie were very well regarded in the area; but son John had a tendency to drink and become disruptive. The *Commercial Advertiser* of April 4, 1905, said, "A trait of his disposition was his exceeding jealousy of young men who paid attentions to his sister."

The *St. Lawrence Republican* elaborated in its April 5, 1905 edition:

> *The brother was harsh, ugly and tyrannical in the treatment of his sister.*
> *He appeared to think it was her duty to minister to his comfort to the*

exclusion of all other men and evinced anger and jealousy when she accepted attentions or devoted her time to others. He was especially vindictive toward any of his sister's young men friends who he thought might wish to marry her and remove her from the family circle.

While the senior Hall was very kind toward his daughter, John treated her abusively and expected her to always be at his beck and call. So when a man of thirty-five named Sumner Hazen began courting Callie, according to old news accounts, John told his sister that he would "fill Hazen full of buckshot," if she dared to marry him. It wasn't because Hazen wasn't good enough for his sister. He had an excellent reputation and seemed to be the perfect match for Callie, who was described as "bright, intelligent, pretty, and of good reputation." It was because John was determined to go to great extremes to keep his sister all to himself.

Hazen had become a widower on July 27, 1900, when his first wife died of typhoid fever, leaving him to raise their precious little girl, Marjorie, alone. The child was only seven when he met Callie Hall, and Callie looked forward to becoming Marjorie's stepmother. But her own flesh and blood was about to crush all of her dreams. When it became obvious that Callie and Sumner's marriage was imminent, John went on a weeklong drinking binge. Then a series of tragedies befell the family in rapid succession. First, on March 24, 1905, just as wedding arrangements were being finalized, a mysterious fire of unknown origin destroyed the Hall house and all that was inside of it, including Callie's bridal gown that she would have worn a few days later—and the modest trousseau she had carefully prepared for her new life with Sumner and Marjorie.

The *Commercial Advertiser* of April 4, 1905, said:

The courtship proceeded, and a few days ago, arrangements were completed for the wedding, when the Hall cottage took fire and was burned to the ground, leaving the family in a destitute condition, even the wedding clothes of Callie Hall being destroyed. The family took up their life in an abject hovel a short distance removed, and here they were living, poorly clothed and fed, at the time of the double tragedy.

One can't help but wonder if John Hall somehow started the fire in an effort to throw a wrench into his sister's wedding plans. Undaunted, Sumner and Callie rode to Parishville four days later and were married at 11 o'clock on March

28, 1905, by the Reverend M.G. Powley. They only had one night together as newlyweds. While they were away, John told several people he should kill Hazen if he married his sister. The events that transpired a day after the fateful wedding vows were taken, and less than a week after the devastating fire, were as follows, according to Callie's sworn testimony taken at the inquest the following day:

> *Sumner and I drove home and got here about 7 p.m. yesterday. We drove a team hitched to a wagon. When we got to the house, I came in. Sumner drove to the barn.* [My brother], *Eddie Wilson, and George Wilson were here when I came in. I said, "Good evening." John said, "Did you go to Parishville the other day?" I said we did. He said, "Are you married?" I said, "Yes."*

With that, John was quoted as saying, "Then I will have to get out," but Callie assured her brother he didn't have to because she and Hazen would be moving out on Saturday and had already been hired to work in a nearby factory. John went to the stairs and got his rubber boots on. The wheel of fate had been set in motion, and Callie could tell by the look in her brother's eyes that he was up to no good. Nelson Hall had just returned from across the road where he was visiting his neighbor, Mr. Cashman. When he walked inside their temporary quarters, he saw Callie, George Wilson and his son, John, who was coming down the stairs. In his testimony, Nelson Hall said, "When he came down, he said, 'Pa, Callie is married.' He took down the lantern, lit it, and went out toward the barn. I and George Wilson followed him out. Sumner was taking the harnesses from the horses." Edward Wilson, who had been helping Hazen with the horses, said that when John first came outside, he marched right up to Hazen and asked if it was true that he had married his sister. Hazen replied that it was. Then John said simply, "Well, all right," and walked into the barn. When he came out, he was carrying a .38-caliber Marlin rifle. Standing about twenty feet from Hazen, John Hall "drew it up and fired at Hazen," Nelson Hall admitted. The ball struck the victim on the collar bone with a downward trajectory that penetrated into the chest.

According to the *St. Lawrence Republican* of April 5, 1905:

> *Hazen called out to his bride that he was shot, and she, who had been watching the proceeding from the pantry window, came out, and she and her father assisted Hazen into the house and toward a lounge, located about eight feet from a window…John Hall, after firing the first shot into Hazen's person, ran out back of the barn. After Hazen had been gotten into the*

house, he returned to inquire of one of the Wilson boys as to the effect of the shot, where Hazen was hit, and the probability of his being fatally wounded. He would not allow the boys to approach him to take from him the gun, and stepping up to the piazza to the window near which Hazen was standing, thrust the rifle barrel through the glass and fired the second shot. After that, nothing was seen of John until the arrival of the coroner. When the officers arrived and took their horse to the barn, they found John lying in the doorway dead. He had placed the muzzle to his eye and pulled the trigger.

Meanwhile, back inside, Hazen was still alive, but he was mortally wounded. The coroner, doctors and constable had all been summoned by the Wilson boys who raced to Buckton to find the nearest telephone station from which to sound the alarm. The second shot, which some later speculated was meant for Callie, had bounced off Hazen's watch, grazed his forearm, and caused only a flesh wound. But the shot that penetrated his chest was lethal, because the doctors had no means to stop the internal bleeding. All they could do was try to ease their patient's suffering as best they could. Hazen, the above article said, could "hardly believe that he was fatally hurt and expected to recover from his injury, until the doctor made him aware of his condition." Yet, even in his darkest hour, he had nothing but compassion for the man who had just sealed his fate. The article said, "While wounded twice at the hands of John Hall, Hazen seemed to cherish no resentment against him. Before he died, he was told that John had killed himself and remarked only that it was too bad he had done so."

At 12:15 that solemn night, Sumner Hazen died; and his new bride wept for the loss of both husband and brother. Papers like the *St. Lawrence Republican* later marveled at the quiet strength of the young widow:

The wonderful nerve displayed by Callie during this fearful ordeal was commented upon by those who witnessed her bearing. She did not miss a single detail of the whole terrible business, and yet retained her calmness and self-possession throughout it all. She attended her wounded husband until he died, and then provided for the wants of her aged father, and proceeded to set things to rights for the burials which must follow.

John Hall was buried April 5, 1905, and Sumner Hazen was buried the day after. Seven years later, on April 9, Nelson Hall, died suddenly at his home in East Stockholm, and no further mention was made in local newspapers of Callie's fate or of the misfortunes of the Nelson Hall family.

THE APPLE-CROWDER DOUBLE HOMICIDE

BLACK LAKE, 1908

The murder, the most fiendish in the criminal annals of St. Lawrence County, was consummated with a shotgun, the wife's father, Jerry Apple, and her brother-in-law…having been shot through the head with buckshot while sitting peacefully at a table playing cards.
—Watertown Re-Union, *May 13, 1908*

When Bessie Apple married Rollin Dunning in 1902, she was only thirteen years old, but the newlyweds told Magistrate John Manson that she was seventeen. Dunning was twenty-one and had already served hard time at Dannemora, and Bessie was not exactly an angel herself. Three years earlier, Dunning, along with Charles Brown and Elmer Crowder, was sentenced to two years in prison after being charged with third-degree burglary and petty larceny for breaking into the W.W. Leonard store in Rossie. Upon his release, Dunning sought the hand of Bessie Apple, whom he had known all his life (or at least thirteen years of it). According to the *Courier & Freeman* of September 16, 1908, when someone expressed concern to the magistrate that Bessie "was a wayward girl and would probably have to be sent away," Dunning dismissed the inference, and the two were married a day later. Wedded life, however, was anything but bliss. Bessie would later testify that Rollin didn't want her going anywhere without him. He insisted that she accompany him when he worked on the farm, hunted, fished or cut wood. He even attempted to prevent her from seeing her own relatives.

Then she listed some of the peculiar behavior he had exhibited during their marriage: He shot at a cow, a pig and even his own dog—lodging a bullet under the pet's skin. And he once whipped a colt and hit another in the eye. His own sister-in-law testified that he once kicked her young daughter before throwing the child on a bed. Suffice it to say, Dunning was a brute, through and through, and he seemed to be growing increasingly volatile, jealous and eccentric by the day. Alcohol only made matters worse. When he was

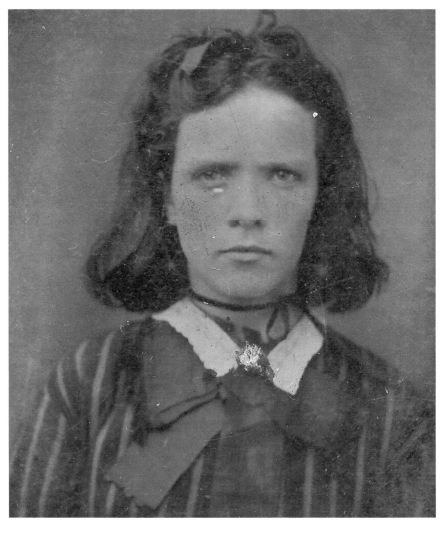

About the age at which Bessie Apple was married; a striking resemblance. *Courtesy of the author.*

drinking, he was a force to be reckoned with. That's why Bessie had begun seeking refuge at her father's shack on Apple Island near the mouth of the Indian River on Black Lake. By all accounts, Jerry Apple, her fisherman father, had a quiet and peaceful temperament that was surely a welcome contrast to the argumentative, unpredictable nature of her husband.

On Tuesday, May 12, 1908, Rollin and his brother, William, left their respective Black Lake homes and set out for a nearby Rossie saloon. From there, they staggered to a hotel bar at Brasie Corners, where they continued to imbibe. Bessie knew what happened every time her husband spent the day barhopping like that. He came home drunk and abusive and looked for any trivial reason to beat her. And if he didn't find one, he made one up. The only way to protect herself was to simply not be there when he returned, so she set out across the swamp to the Apple Place. That evening, when the two men returned home, she was gone. William's wife told them that Bessie was at her father's, and Rollin Dunning became furious. According to early articles, he didn't want his young wife seeing her brother-in-law, Albert Crowder, whom he felt was becoming too friendly with his wife. The *Watertown Re-Union* the next day said, "Instantly aroused to a pitch of rage, Dunning rushed to the lake shore, jumped in a rowboat and rowed to the Apple Island home." That article went on to describe the destination as "a

William Dunning and his family. *Courtesy of the St. Lawrence County Historical Association.*

squalid shack that served as the sole residence of the girl's father and his friend, Harder."

Old Ben Harder was a footless, wheelchair-bound veteran who lived with Jerry Apple. He had no choice but to witness the carnage that followed; he was smack in the middle of it and couldn't have helped his friend or escaped, if he had wanted to—and he *did* want to. Because of that, Harder gave the most convincing testimony at the trial. He said that on the evening in question, he was sitting in the living room in his wheelchair, and Jerry Apple was nearby at the kitchen table, playing cards with daughters Bessie and Diantha, as well as Diantha's husband, Crowder. There was a rap at the door, and Apple hollered for whoever was knocking to come in. Dunning

Inside a similar shack. *Courtesy of the St. Lawrence County Historical Association.*

stepped inside, glanced around, spotted his wife sitting at a table with Crowder, and then turned toward the stove to warm his hands. He scolded Bessie for leaving home and told her it was time to go. She refused. But she told him she'd see him to the door. There at the door, he was overheard asking the young woman why she left, and she told him it was because he had abused her. They whispered a moment longer, before Dunning ducked away, blurting aloud, "You'll be sorry." Harder, from his vantage point near the window, could see Dunning go around the house to retrieve a double-barreled shotgun he apparently had brought with him, in case he needed it.

The *Watertown Re-Union* described the horrifying events that ensued in the next day's paper:

> *Deliberately aiming the weapon at his aged father-in-law, Harder says, the young man fired through the window at Apple, who sat within two feet of it. The charge struck the father-in-law full in the left jaw, killing him instantly. Never moving a muscle, the man, with his hands still clasped over his white-haired head, dropped to the floor.*
>
> *The first shot was immediately followed by another which struck Crowder in the neck as he was running to a place of safety. He, too, fell to the floor, meeting with instant death.*
>
> *Dunning next appeared at the door of the cottage, where he stood and surveyed the gruesome work of the past few minutes.*
>
> *It was at this moment, while the two women and old Harder, the eye witnesses to the violent deaths of their relatives and friends, gasped with horror of the situation, that Dunning, making an exclamation of surprise at the sight of the bleeding forms, told Harder that two men were just at the house and had fired the fatal shots.*
>
> *"You're a liar," shouted the almost-helpless Harder. "You did the deed, and alone."*
>
> *Despite his crippled condition and his old age, Harder grabbed Dunning, hurling him to the floor, crying meanwhile to the shuddering women who were huddled in fear in a corner to bring a rope that they might tie Dunning up. Unable, in their terror to move, the women did not respond, and Dunning was soon able to break away and make his escape.*

Dunning left the scene of the island carnage and went to justice of the peace Alvin Young whose farm was a mile up the road on the mainland. He told Young that Apple and Crowder had been murdered and that he

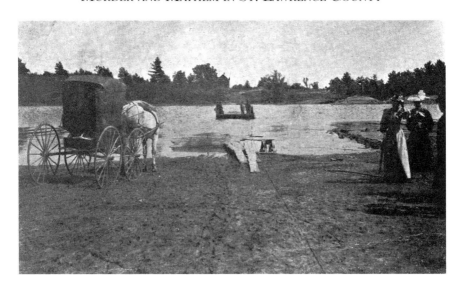

A boat on Black Lake. *Courtesy of the St. Lawrence County Historical Association.*

was being accused of the crime. When Dunning insisted he hadn't done it, the justice told him to go home. Young then headed to the Apple home with neighbors Newman and VanNess to check out the bizarre story. When they reached the homestead—and saw that it was no joke—the appropriate authorities were notified. By daybreak, the village of Rossie was abuzz with news of the crime. A warrant was issued for Dunning's arrest, and he was found on his farm at about 8 a.m. and taken to Rossie where the assistant district attorney Crapser and Sheriff Hyland were summoned. Dunning fed them a tale about two men he had seen running away from the Apple home after he heard gunshots in the night. A search of his premises and inspection of his 12-gauge Belgium shotgun told a different story—and so did countless witnesses to his actions before, during, and after the murders.

In the ensuing two-day murder trial—said to be the shortest murder trial in the county as of that date—on September 7, 1908, Dunning's court-appointed attorney, Arthur W. Orvis, tried to make a case for insanity for his client, saying he had become mentally imbalanced due to domestic issues. Judge Chester B. McLaughlin reminded the jury that it must determine whether the murders were deliberate or the result of an insane impulse. Luckily for Dunning, they chose the latter, finding the defendant guilty of murder in the second degree. He was sentenced to twenty years' hard time at Auburn and Dannemora, but he served only fifteen before being released

The Apple-Crowder Double Homicide

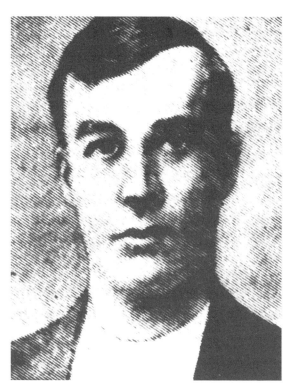

Rollin Dunning's portrait, which was widely distributed to early news media.

on good conduct. The *Northern Tribune* of September 26, 1923, said he had returned to the area and was working on the road between Hailesboro and Gouverneur. Some in the community were surprisingly sympathetic to the ex-convict, believing that Bessie had provoked him to the point of murder by not obeying him and returning home with him. It was a preposterous justification for his actions; and it was unfair to the young woman who was merely trying to escape his abuse. She couldn't have imagined the extremes to which her husband would go.

Although Bessie moved back to her family home on Apple Island, Dunning never attempted to reconcile with her. In 1924, however, Bessie found herself in deep water. According to the *Hammond Advertiser* on October 9 of that year, she—along with her sisters, Lena and Diantha—was wanted in a series of robberies and other crimes in the area. The article stated that a warrant was out for the arrest of Bessie, who had left for downstate and was expected to be apprehended shortly. Rollin and Bessie had not lived together since he was released from state prison. Apparently, Bessie and Blair Conroy wore male clothing while committing robberies and chained at least one

The razed Apple homestead. *Courtesy of the St. Lawrence County Historical Association.*

victim to a tree on the Swamp Road between Rossie and Brasie Corners, before their plans were foiled by an approaching vehicle.

Rollin Dunning made news just one more time for illicit activities. Five years after his release from prison, when he was forty-seven years old, he was accused of improperly living with his niece (William Dunning's eighteen-year-old daughter), according to the *Gouverneur Free Tribune* of February 1, 1928. Evidently, others living in the Newton Falls vicinity near the small hut he lived in a mile from the village became alarmed by this domestic arrangement and filed a complaint. He was charged with "disorderly conduct and outraging the public decency" and was sentenced to thirty days in the county jail. The young lady received a twenty-day sentence. In 1936, Dunning finally got around to divorcing Bessie Apple when he decided to marry a Syracuse woman. And in 1941, he passed away at his home in Long Branch, a hamlet of Syracuse, at the age of sixty. The two-story shack where the double homicide occurred eventually burned to the ground, and Diantha Crowder, to whom it had passed, sold the stigmatized property.

HARRY HOSMER'S FATAL BIKE RIDE

FINE, 1908

Youth Found Guilty of Murder in First Degree. Insanity Defense Didn't Hold. Evidence Showed That He Was a Bad Boy in Which Almost Every Instinct Was Criminal and Degraded.
—Massena Observer, *January 14, 1909*

Wayward teenager Leslie Combs had repeated scrapes with the law. The *St. Lawrence Republican* on September 30, 1908, said: "He was first sent away to the Rochester Industrial School for larceny and upon his return broke into another store. He was released upon suspended sentence but almost immediately committed another robbery. For this, he got a term at Dannemora prison and was released only Friday last."

Combs was eighteen years old and looking for trouble on September 26, 1908, when he returned home from prison to his parents' house in Fine, after serving two years of a three-year sentence for burglary. He was considered a half-witted degenerate by local media of the time, and his actions that day did little to dispel the impression. Even his own parents— Mr. and Mrs. Hiram Combs, who were respected citizens in town—told reporters that they dreaded what would happen when their son was released from prison. They feared he would return worse than he was when he went in. They were right.

According to the *Massena Observer* on January 14, 1909, the day after Combs returned home, he "ate breakfast, shot at a mark once or twice,

played the organ, and read some; ate his dinner, and in the afternoon, he and his father went into the woods and fought fire a couple of hours." The wildfires were becoming out of control in the neighborhood at that time, and every able man in the vicinity was called upon to help stop them. That evening, about half past nine, the family retired. But Leslie Combs didn't dare close his eyes. He lay in bed thinking about ways to quickly get enough money to get out of town and head to Washington. He and a Dannemora cellmate had discussed plans of moving there. When he felt confident his parents were asleep, he got out of bed, took a .32-caliber rifle and some cartridges and went to what was then known as the Cheese Factory Hill. As he stood on the dark road lighting a cigarette, waiting for an opportunity to present itself, "he saw a man on a bicycle with a lighted lamp coming along the road toward him." That man—the unfortunate soul who happened to be in the wrong place at the wrong time—turned out to be Harry Hosmer.

Unlike Combs, Hosmer had a stellar reputation. He was twenty-one years old, hard-working, exceedingly helpful to all and very well respected in the community. He had ridden his bike into town to attend church that evening and was on his way home alone after saying good night to friends when the gunman appeared. That section of the Cheese Factory Hill road was fairly steep, so Hosmer is believed to have been walking his bike up the hill when he was accosted. Combs made him put his hands in the air as he searched him from behind and helped himself to a gold watch and nine dollars (sources vary on the actual dollar amount taken). Then, with the butt of the gun against Hosmer's back, Combs ordered his victim to start walking, warning him that if he made any attempt to yell for help, he would be shot dead. A quarter of a mile down the road, Combs told Hosmer to turn off the road and head into the woods. Hosmer resisted, and the two struggled from the road to the sugar house, where Combs knocked Hosmer to the ground and kicked him. Then, when he had him in a vulnerable position, he shot him at close range through the chest. As Hosmer lay dying, Combs allegedly took a handkerchief, tied a large knot in it, stuffed the knot in Hosmer's mouth, and tied the ends tightly around his victim's neck to keep him from making any noise.

Moments before, Harry Hosmer hadn't a care in the world; and now he was on the brink of death—the victim of a senseless, cold-blooded crime. Combs later told authorities he shot Hosmer because he thought he was holding out on him and that Hosmer actually had more money on him that he wasn't handing over. But he didn't. The pointless murder was all for naught.

Harry Hosmer's Fatal Bike Ride

Harry Hosmer's portrait, which was widely distributed to early news media.

Combs was intelligent enough to grasp the futility in running. As he neared his own home, he realized that his thumb print, which was on file at Dannemora, would match the prints left behind on the victim's bike and lantern; and, having just returned from prison, he would surely be the first person authorities would suspect.

The young killer confessed his crime to his parents as soon as he walked in the door. He told them he didn't know the victim but asked his mother to go to the crime scene and see if she could help him. The request was not out of the goodness of his heart, mind you. According to the *Massena Observer* of January 14, 1909, Combs "told several people that he hoped the man would live twenty-four hours, because then it would be murder in the second degree"—*Prison 101*. But even if he ended up being charged

with first-degree murder, he didn't care if he got the electric chair. He said the prison physician gave him only five years to live, anyway, on account of tuberculosis. Meanwhile, his father summoned Constable Locke; and before long, Hosmer's body was found, with his bicycle nearby, right where Combs said it would be. Because the coroner could not reach town until the next morning, the body was covered with a sheet and guarded throughout the night. Coroner Drury, accompanied by Drs. D.M. Taylor and James Wiltaie, had the body of the deceased moved to the home of Aaron Hosmer, the victim's father, where an autopsy was performed. The postmortem examination found that he had been the victim of a single gunshot wound, and that the bullet had passed through the lobe of the left lung and the heart and was lodged in the chest cavity.

Combs was arrested by deputy sheriff Charles Locke and confessed to the murder at 1 a.m. Sheriff Nilie M. Hyland was forced to handcuff himself to the prisoner and sleep in a hotel in Fine, after obtaining Combs's confession, because he was concerned that Combs might be lynched by angry residents of the village and friends of the victim. He had done the same thing earlier that year with Rollin Dunning when he was guarding him at Rossie and was getting used to having prisoners attached to him for that purpose. The next morning, Hyland delivered the killer to Canton, where a large crowd had gathered in anticipation of his arrival. Along with deputy sheriff Farmer, the two men managed to get Combs inside the St. Lawrence County lockup in one piece—a miracle considering the unruly mob outside. Combs was placed in Rollin Dunning's old cell, which officials had aptly dubbed "the murderers' cell," to await trial. Throughout his incarceration, he remained oddly detached and oblivious to his predicament.

On January 4, 1909, the supreme court trial commenced. The case was cut and dried, with Combs having admitted freely to the murder. The only thing left to do was determine whether he was sane at the time. The defendant's attorney did his best to elicit a finding of insanity for his client. So when the verdict to convict him of murder in the first degree came in, witnesses were taken aback, according to the *St. Lawrence Republican* of January 13, 1909:

> *Witnesses at the Leslie Combs murder trial which terminated at Canton yesterday with a verdict of conviction, passed through here today en route to their homes in the town of Fine. They said they were somewhat surprised at the jury's verdict, as they had thought that a verdict of insanity would be returned, Combs' attorney having brought strong evidence to show that the*

St. Lawrence County jail in Canton. *Courtesy of the St. Lawrence County Historical Association.*

man was insane. However, there seems to be quite general satisfaction at the outcome of the case, as the murder was one of the most atrocious ever committed in this county. Lawrence Russell, attorney for the condemned man, says that there will be no appeal. He says he has talked it over with Combs, and he seems satisfied with the verdict and does not care to have an appeal take from the decision of the jury.

The same article said, "Combs knew what he was doing and was well aware of the quality and seriousness of his act. If strict interpretation of the law is what is desired, no jury ever acted with more wisdom." The jury needed barely an hour to reach their verdict of guilty. Judge Van Kirk, without further ado, sentenced Combs to be electrocuted at Dannemora sometime in the week of February 15, 1909. The *St. Lawrence Republican* said, "The defendant received the verdict as he has received everything else during the progress of the case, in an impassive manner." At least, that's how he appeared outwardly, until he attempted suicide by morphine overdose.

The same paper, on January 20, 1909, said:

Sheriff Hyland succeeded in getting from his prisoner a confession as to where he got the morphine which he took after his sentence and which made

The east cell block at Clinton Prison in Dannemora, where Leslie Combs was electrocuted. *Courtesy of the author.*

him so sick…that it was thought he would die. According to Comb's [sic] story, he bought the drug at Plattsburgh when he was on his way home from Dannemora last September and kept it sewed in his vest, taking a little from time to time. His last dose he took while in his cell at the jail, just before leaving for the train at Canton.

Nevertheless, the sheriff accomplished his task of delivering the young prisoner to Dannemora on January 11, 1909. Barring unseen circumstances, he would be executed on Tuesday, February 16. Although Combs had asked that his attorney, Lawrence Russell, not appeal the verdict, Russell nevertheless asked Governor Hughes to commute the sentence to life imprisonment, owing to the "youthfulness of the murderer." He was only eighteen, after all. The governor responded that he would not interfere; Combs was the type of criminal, he said, who would remain a menace to society as long as he lived. And that was that.

Like other prisoners before him and since, Combs turned to God for the first time as he approached his imminent demise. He was baptized in the Catholic faith two weeks before his execution by Father Belanger, the chaplain of the prison, and he made his First Communion on February 11, 1909. The Saturday before his execution, Combs received a special blessing from the Right Reverend Henry Gabriels, Bishop of Ogdensburg—a charitable act of compassion from a high dignitary of the church—prompting Combs to display a rare glimpse of emotion and humility. The day before his execution, Combs asked the warden to send his mother $1.85 that he had brought to prison with him. It was all he had left for earthly possessions. He ate his last meal of ham, potatoes, cake, custard pie, bread and butter, oranges and bananas at 9 p.m. and then slept for four hours. Father Belanger spent the night in Combs's cell to provide spiritual support. Combs was said to have prayed almost continuously. The next morning, he received his final Communion at 5 a.m. and prayed with his priest for the next hour. The *St. Lawrence Republican* of February 24, 1909, said he "met death unflinchingly, walking to the chair unassisted, and was apparently as calm as any man in the room while the officers were strapping him into the chair."

At the last moment, he received a final absolution and a plenary indulgence in articulo-mortis—in the article of death. He then very courageously walked to the [electric] chair, holding in his hand a large crucifix and repeating with the priest the invocations: "Jesus, Mary and Joseph, I give

you my heart and soul. Jesus, Mary and Joseph, assist me in my last agony. Jesus, Mary and Joseph, may I die in peace in your blessed company."

Combs took his seat in the fatal chair at 5:59 ½ and Officers Mead and Bates at once proceeded to strap him in, while Electrician Davis adjusted the electrode on the top of the head…the electrician threw the switch into place, and a current of 1,800 volts, seven and a half amperes, shot through the condemned man's body…The man was at 6:10 o'clock by Dr. Ransom pronounced dead.

The postmortem examination showed Combs did, indeed, have tuberculosis and that his heart was greatly enlarged. His remains were buried in the prison cemetery, because his mother—who wished to have her son's remains sent home to Fine—did not have enough money to have the body shipped to her.

BLOODBATH AT BUCK FARM

STOCKHOLM, 1917

*He came, as you have learned, under an assumed name. He came hiding his past,
like a wolf in sheep's clothing.*
—District Attorney Dolan at the trial of Alvah Briggs

Albert "Frank" Driggs was no saint when he appeared in Norfolk in
September 1916 looking for work at the paper mill. And he was no
Frank Driggs, either; he was Alvah Briggs, twenty-five years old and a
convicted child molester who had just been released from Dannemora days
earlier, having served five years for brutally raping a seven-year-old girl in
September 1911 down in Dutchess County. *Seven years old.* He was originally
sent to Sing Sing but had to be transferred to several prisons on account of
disorderly conduct. Finally, he was placed in Clinton Prison at Dannemora,
where he boasted about having had the opportunity to sit in the electric
chair at Sing Sing. The next time he was afforded such an opportunity, he
wouldn't have a chance to brag about it after the fact.

The people of St. Lawrence County knew nothing of this man's felonious
past or the fact that he was not who he said he was. How could they? He was
using an alias at a time when it was far easier to pull off such a stunt than it
is today.

(For the remainder of this story, I refer to him by his true name, Briggs;
however, news articles may refer to him as Driggs, because his true identity
wasn't confirmed until after his death.)

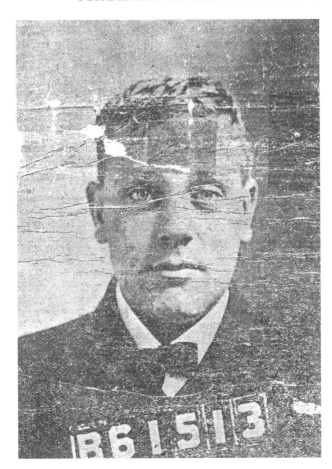

Alvah Briggs's (aka Frank Driggs) mug shot. *Courtesy of the Stockholm Historical Organization.*

Briggs seemed like a quiet, polite and unassuming young man looking for work when he met the LaDues in Norfolk. So brothers Henry "Sandy" and James LaDue—forty-five and forty-eight, respectively—hired him as a farm hand at the old Buck farm in Stockholm which they owned and operated. The farm was located a half mile off the Potsdam–Winthrop Road, about ten miles from the village of Potsdam. Their sister, Mrs. Josephine Rogers, and their young niece, Harriet LaDue, also lived on the farm. But of the entire household, only Harriet lived to tell what happened on Thursday, June 21, 1917.

According to the eighteen-year-old girl, whom papers described as an attractive young woman of medium height and light complexion, Briggs had worked for the family since the previous September—the same month he was released from Dannemora, unbeknownst to Harriet or her aunt and uncles.

Bloodbath at Buck Farm

She described Frank Driggs as having a rather unpredictable disposition and said he "had sulky days when he would be melancholy," according to the *Madrid Herald* of June 28, 1917. In the days leading up to the Buck farm bloodbath, Briggs complained of not feeling well. In hindsight, some later wondered if he only feigned illness as a reason to stay inside, where he could be around Harriet. On Tuesday, he went to see Dr. Buck in Winthrop and then returned home to sleep. Wednesday he puttered around the house, still under the guise of not feeling well; and on Thursday—the day he snapped—he helped do chores before accompanying Mrs. Rogers (the aunt) and Harriet to Holmes Hill and Winthrop. After the three returned and the family ate supper, Briggs stayed inside while the women went out to milk the cows. Mrs. Rogers finished her share of the chores first and returned inside the farmhouse, where Briggs was sitting in a rocking chair.

Harriet LaDue's photograph, which was shown in the *Courier & Freeman* after the murders. *Courtesy of the Stockholm Historical Organization.*

After Briggs turned himself in at the Potsdam police station, Harriet told authorities what transpired:

> *Mrs. Rogers asked me to go to one of the neighbors for a hot water bottle for him. I went. I came back in about 15 minutes, and when I came in the door, he grabbed me and told me he was going to carry me away. I stood and pleaded and argued with him. [Uncle] Jim…came in. He asked me what was the matter and if Driggs had tried to harm me. I told him he hadn't.*

Harriet did, however, later testify in court that she told James LaDue, when he asked what was wrong, that she was fearful Briggs *might* hurt her, even though he hadn't harmed her yet. Neither she nor James was aware that Mrs. Rogers had already been slain by Briggs and that her aunt's body had been dragged out of sight.

Harriet continued:

> *Then I saw Driggs come with a gun. It was a Winchester gun we had to shoot crows with. He hit [Jim] in the shoulder. I saw the blood spurt. He got up and started to fight, when Driggs hit him with the end of the gun. Then he took me upstairs and bound and gagged me. Finally he left me.*

What would later be learned was that when Briggs shot James the first time, he thought he had killed him; so he began carrying Harriet to the stairs to take her up to his room. But then James got up and came toward him in an effort to save Harriet, and that's when Briggs shoved her down behind him and shot again. That time the bullet missed, but it didn't matter; James collapsed at the same moment, mortally wounded from the first shot. Briggs then carried the girl up the stairs, as Harriet said, tied her up, gagged her and raped her. At that point, her other uncle, Henry, came inside. She heard him ask Briggs where Jim was; and then she heard Henry pleading for his life before the sound of two gunshots pierced the night. You can imagine her shock at that point—tied up, raped by a homicidal gunman and forced to helplessly bear witness to her loved ones' horrific murders. She had no choice but to be obedient or she would meet the same fate.

> *Driggs came back upstairs and told me to dress. I did. He gagged me. Then he went out, and as I found out, went to Steenberg's [a neighbor's] to get a horse. It must be that he picked up something to eat, for I heard dishes.*

He picked me up and carried me to the wagon. I lay in the bottom for four miles. Then Driggs said, "I realize now what I've done. I'll give myself up." I didn't know where we were, but I saw lights ahead and I think it must have been two miles from Potsdam when he got out, held the gun to his head, and asked me if he'd shoot. I told him if he was any man, to confess to the authorities. He said, "I am terrible sorry." And he asked me to forgive him. I said I would to quiet him. It must be that he murdered Mrs. Rogers, too, but I didn't see him, and I don't know when. I asked him, "Then you murdered all three?" And he said, "Yes."

The two, Harriet and Briggs, then continued on to Potsdam, where they eventually found the police station, and Briggs turned himself in, saying to Officer Stone simply, "I'm a murderer." When questioned about his identity, Briggs gave his name as Albert Driggs and told the police chief that he was born in Lincoln, Nebraska, and that he was an electrician by trade. He claimed to have come to Norfolk in search of work at the mill, and that was where he met the LaDues, who were visiting relatives in that village. He added that he had left the LaDue farmhouse some time previously to enlist in the navy but was denied because of a hearing impairment, so he returned to the LaDue residence. Briggs was described as Swedish with a sandy complexion, about five-feet, seven-inches tall and weighing approximately 150 pounds.

Armed with Harriet's statement and Briggs's own unabashed confession, the officers and local news reporters set out at once for the farm. Briggs was locked up, and the sheriff and coroner were summoned. As for Harriet, the paper said, "She was obviously under a terrible strain from her ordeal, but managed to finish before she broke down. She was carried from the room by the officers and taken to the home of Chief Leahy, where she is under the care of Dr. S. P. Brown." Authorities arrived at the scene shortly before daybreak. A few nearby farmers and the coroner had already preceded them. The homestead was eerily quiet, with only the sound of baby chicks chirping. The family's dog was asleep at the back door, oblivious to the carnage within. Before long, a crowd of about 200 had gathered outside, but "admittance was denied to all but officials and newspaper men."

The officers proceeded inside through the unlocked front door, carrying their lighted lanterns, as it was still dark outside. The parlor seemed fine, with nothing amiss; there was still hope that it had been a false report. But then they entered the bedroom at the back of the parlor, and "under the bed

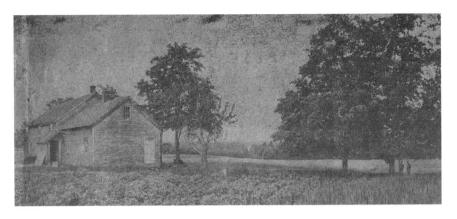

An early image from the *Courier & Freeman* of an auction at the LaDue homestead shortly after the murders. *Courtesy of the Stockholm Historical Organization.*

was found the body of James LaDue, lying on his back, one bloody hand lying extended into the room." A smeared blood trail across the hardwood floor indicated he had been dragged out of view. Briggs shot James LaDue in front of Harriet and stuffed his body under the bed before anyone else arrived. The autopsy found that James had been shot once in the right shoulder, "the bullet passing across to the heart." The other shot Harriet heard at that time would later be found lodged in the wall near the stairs, an apparent miss. The kitchen to the left of the parlor and bedroom was the next stop. There lay the body of beloved Dr. Theron Jenkins, much to the horror of those present who expected to find only three victims, not four.

According to the *Madrid Herald* referenced above:

> *A stove stands in the northeast corner of the room, just beside a door leading into the dining room....The body of the doctor lay with his head on the floor, his feet in the wood box behind the stove. A bullet wound was through his heart. Subsequent investigation showed his car at the rear of the house, and inquiry among the neighbors elicited the information that at the request of Driggs, Mrs. Rogers went to a neighbor's to phone for him to call at the house late in the afternoon. It is believed that he was shot as he entered the kitchen door...Dr. Smith paled as he recalled he had been called to attend Driggs, but was unable to go. It saved his life.*

The good doctor had arrived as requested, and, finding nobody about, he had stepped inside through the kitchen entrance and was shot and killed on

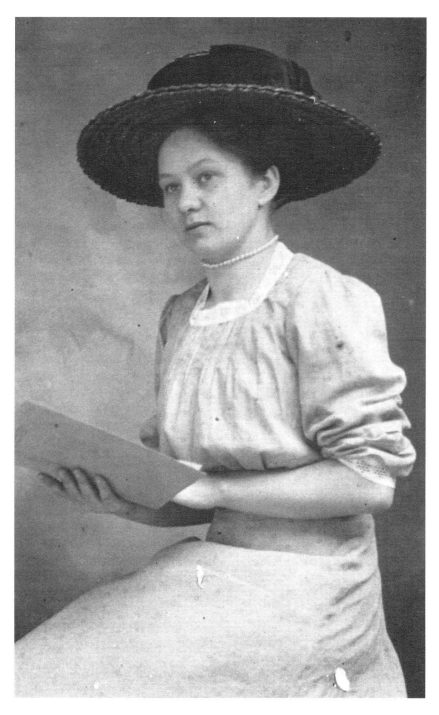

Frances Goodnough Jenkins, widow of Dr. Theron Jenkins who was murdered by Alvah Briggs at the LaDue farm. *Courtesy of the Stockholm Historical Organization.*

the spot. Nearby were the bodies of Mrs. Rogers and Henry LaDue. The latter was face down in the middle of the floor near a large pool of blood, having been shot twice through the back as he attempted to flee; his lovely young wife became a pregnant widow that day. Mrs. Rogers's lifeless body was on its side across the room, against the wall where it had been dragged. Little blood was visible from the front side of her, because she had been shot once in the back, but the bullet lodged in her right breast. Briggs admitted to killing her first while Harriet was at the neighbor's fetching the hot-water bottle for his benefit.

Once authorities confirmed the validity of the killer's farfetched confession, Briggs was taken to Canton and held in the St. Lawrence County lockup to await his October murder trial. Two months after the Buck farm massacre, his real identity became known. The *Courier & Freeman* announced on August 8, 1917, "Frank Driggs an Ex-Convict." The article, identifying the prisoner as Alvah Briggs, said Briggs, while in the St. Lawrence County Jail, told of being at Sing Sing—where he was known as Al and sitting in the electric chair there.

The *Commercial Advertiser* confirmed the suspicion that Driggs was actually Briggs:

> *Upon learning that Frank Driggs…was thought to be Alvah Briggs, Probation Officer John M. Nichols recalled that he had that name on his letter file. Looking up the name, he found that in communication from George W. Sisson of Potsdam, dated July 1916, the signer stated that he had been asked to find employment for an Alvah Briggs, who was serving a sentence in Dannemora prison, and who was soon to be released, on condition that he obtain employment. The letter stated that it was thought that the probation officer might know of something the man could do. Officer Nichols communicated with the prison warden to get further information and learned that Briggs had been sentenced to the prison for not more than nine years and not less than five years on a charge of rape, committed on a seven-year-old girl. It was further stated that the prisoner could be released in September 1916, if work could be found for him so that he could get to it from the prison.*

The trial in the supreme court in Canton commenced on October 29, 1917. In her soft voice, Harriet LaDue calmly told of the single murder she had witnessed, as well as the gunshots she had heard, her sexual assault by Briggs and of their arrival at the jail in Potsdam, where he turned himself

The St. Lawrence County courtroom where Alvah Briggs attempted to intimidate Harriet LaDue. *Courtesy of the St. Lawrence County Historical Association.*

in. Briggs did his best to intimidate her in court, according to the *Courier & Freeman* of October 31, 1917. Because he was partially deaf, he was allowed to sit near the witness box so he could hear the testimony:

> *While Miss Ladue was testifying, Briggs's eyes never left her face, and his gaze finally undermined her composure. On direction of the Court, who was quick to sense the situation, Briggs was ordered back to his original place just inside the lawyers' rail with his counsel. The sneering smile which he wore when he resumed his seat did much to alienate from him any sympathy among those in the court room.*

The *Massena Observer* corroborated the incident in its November 1, 1917 paper, saying, "At first the witness did not appear to mind his presence, but once she looked down at him, then she shuddered and shrank into the witness box and there burst into tears. Driggs sat there with a smile on his face." Harriet, nevertheless, regained her courage and continued on with the difficult testimony. Attorney Herman J. Donavin, summing up for the defense, attempted to portray the crime as perhaps not being premeditated but rather the result of a man seized by an urgent sexual frenzy that needed to be satisfied at any cost, *if* the defendant was the man responsible for the murders—regardless of the fact that he had already confessed to the crimes.

Donavin said:

> *Men are peculiarly constituted…There are some men undoubtedly who are highly sexed. There are some men who, when the sex passion takes possession of them, might be likened unto animals, and you men who are farmers know what has happened in some instances with animals. That might have been so with this thing, assuming…that this defendant is responsible for the acts committed there; it might have been so that this frenzy took possession of him, and that he desired sexual intercourse, and that it was an overwhelming desire, and that he could not resist it, and that he became insane, frenzied, and then seeking to satisfy himself, and with no intent at all to commit murder…he was interrupted, or that he was caught, or that he murdered without any premeditation at all in this frenzy, because he was either stopped in the commission of it or hindered or hampered; and, as those people came in successively, one was hardly out of the way before he killed another. That is always assuming, gentlemen, that this man is the man who perpetrated the deed…Now, if this is so, and those crimes were committed without premeditation, he is entitled to the benefit of the doubt; and your verdict will be not guilty.*

District attorney James C. Dolan, who carefully laid out his case to prove that the cold and calculated murders were premeditated, found the defense's argument ridiculous, saying:

> *Gentlemen of the jury, the attorney for the defense has said that this is abnormal. But that doesn't excuse a man for doing it! He says it was done in a fit of sex frenzy. But that cannot excuse a person. These acts were done premeditatively and deliberately…Counsel has said that there is a wide divergence in men's minds. We cannot conceive of a man taking an eighteen year old girl and assaulting her after killing four persons!* But he did it! *Wasn't every one of the acts a result of the other? Didn't each one of them give evidence of mature thought? Doesn't each one of them dictate that he had his senses? Didn't he put up the curtain* [in the bedroom before raping Harriet there]?

Dolan went on, describing the actions of the defendant and reminded the jury that Briggs even had the presence of mind to pack a bag containing a frying pan, meat and breads to eat in the wild. The fact that the defendant

put such careful thought into each action (i.e. dragging the bodies out of view before the next victim entered, preparing an away bag, locking the doors before they left, putting up the curtain, and so on) may have been the determining factor in the jury's verdict. The case went to the jury at 11:30 a.m., and jury foreman Herbert F. Olin announced their verdict of guilty at 2 p.m. Judge Van Kirk sentenced Briggs to death at Sing Sing. The date of the execution was originally slated for December 10, 1917; but, after a reprieve, it was changed to June 13, 1918. During his second incarceration at Sing Sing, Briggs was a mason working on the death house, in which he and three others would soon be executed. The *Courier & Freeman* of June 19, 1918, said that, as Briggs walked to the electric chair at 11:03 p.m., "His face wore the same smile which came to be associated with him at the trial, and the same swagger characterized his gait across the room." He settled himself in, while the guards adjusted the straps and mask, and the prison physician gave the chief electrician at the switch the nod. Ten minutes after he entered the room, Alvah Briggs was dead. He had made no last-minute confessions and had not spoken a single word after entering the death house. But the last thing he allegedly said in his jail cell was, "Tell them up North, I've got no hard feelings."

WHO KILLED
BESSIE WHITE?

MASSENA, 1917

Beautiful Massena Girl Murdered by Negro Fiend Who Attacks Her!" That was the headline of the *Ogdensburg News* on Friday, October 5, 1917. Can you imagine a headline like that in today's papers? It was followed by a blurb at the bottom of the page saying, "One of the most gruesome crimes ever recorded in the history of this section was enacted in Massena when Miss Bessie White, a refined and charming young girl, met death at the hands of a passion-enraged negro." Two days later, the same paper retracted its earlier position and ran an article called, "No Evidence Obtainable That Negro Held in Jail Here is Guilty."

At first, it was automatically assumed in 1917 that Bessie White had been killed by an African American man, simply because the Aluminum Company of America (Alcoa) had recently hired a number of black, transient laborers, some of whom had been arrested for various infractions around town. Thus, erroneous assumptions ran rampant following Massena's only unsolved murder. Everyone seemed to be thinking: Surely, one of our own couldn't have committed such a vile act. But unsubstantiated conjecture wastes a lot of valuable time and resources and often leads investigators down the wrong trail. This is how killers get away with murder, and perhaps it's why Bessie White's murder was never solved.

Bessie, the daughter of Mr. and Mrs. Moses White of Maple Ridge in Brasher Falls, was only twenty-two years old when she was dragged off the road on October 3, 1917, as she walked past the Bridges Avenue high school construction site near Elm Circle and was beaten to death. Years later, after

Early Alcoa laborers in Massena. *Courtesy of the St. Lawrence County Historical Association.*

the current high school was built on Nightengale Avenue, the old high school became the junior high I remember from my youth. The building was eventually razed, and today the Creative Playground and public ice-skating rink occupies the very spot where Miss White was brutally slain. Her futile death cries have long since been replaced by the laughter of children at play. The cheerful surrounds belie the tragic history of the property's past.

At the time of Massena's most sensational murder case, Bessie had been working as a live-in maid for Edwin Fremont "E.F." McDonald and his wife, Emma, for three months. The McDonalds were well respected within the community, and they thought the world of Bessie. From 1897 to 1906, Mr. McDonald was co-owner of the *Massena Observer* with partner Leslie C. Sutton, and the paper was conducted under the firm of Sutton and McDonald. McDonald then concentrated his efforts on academic improvements in the region and was dubbed the Father of State Aid to Schools for his tremendous involvement in getting the law passed. He was a volunteer fireman and the director of the First National Bank and Trust Co. of Massena from 1905 until his death in 1943. But the role he was perhaps most known for was that of commissioner of schools, or district superintendent, an elected position the high-caliber educator held responsibly from 1916 until 1936.

While all was well on the career front, McDonald suffered a series of unfortunate tragedies on the home front during his first two years as

superintendent. First, Bessie was murdered just 150 feet from his Elm Circle house. Then, malicious rumors of his involvement were published in an Ogdensburg daily newspaper, creating quite a scandal. And Emma McDonald, his beloved wife, was failing in health. Their only child, Lloyd— who had graduated from St. Lawrence University in 1915 and was teaching in Greenport, Long Island, at the time—returned home for the holidays that year, while the investigation into Miss White's death continued, to provide moral support to his grieving parents. It's a good thing he did, because three months later, he and his father were bereaved again. The *Courier & Freeman* of March 20, 1918, said, "The death of Mrs. Emma Shields McDonald occurred at her home in Massena Sunday after a long, lingering illness." The tremendous stress the esteemed couple had recently endured surely hastened her decline. Mrs. McDonald never lived to see the killer of her young maid brought to justice; nor has anyone else. While no more is known today than at the time of the murder, the public details of the case follow.

October 4, 1917, was a day Massena chief of police Benjamin Demo would never forget. It's not often that a small-town crime makes a paper like the *New York Times*, but the murder discovered on his watch that morning did.

Even before the local weeklies reported it, the *Times* of October 5 said:

> *Miss Bessie White, 22 years old, of Massena, was murdered by an unknown assailant last night in that village.*
>
> *The body was found early this morning by a workman under a temporary wooden walk. The authorities are investigating.*
>
> *Miss White was on her way to the business section from the home of E. F. McDonald, School Commissioner. Her route led past a new school building, the yard of which is littered with material and traversed by a temporary wooden walk. She was apparently attacked while passing the grounds.*

Bessie left the McDonald residence around 7 p.m. on October 3, 1917, to purchase some postage stamps for Mrs. McDonald and a few items for herself. It was raining lightly, so she grabbed her hat, an umbrella and her overcoat. But her white stockings and shiny black shoes didn't stand a chance. They became increasingly soiled with every step she took, as pebbles and mud kicked up from her heels. She stopped at Will Smith's store to get a lamp wick and at Jerd's Market to pick up some salt pork. And then

she treated herself to a moving picture at the Star Theatre downtown. She rarely went on such an outing alone (usually, her best friend accompanied her), and she had no known suitors at the time, but she seemed to be enjoying herself nonetheless. Authorities believe Bessie headed back to the house on Elm Circle shortly before 9 p.m., which is when witnesses heard suspicious sounds in the Bridges Avenue area. The McDonalds told police they believed she had returned quietly that night without disturbing them. The *Courier & Freeman* reported on October 10, 1917, that Mr. McDonald first suspected something was amiss when he heard a commotion across the street at the school the next morning. The article said he then threw on some clothes and "ran down to the school and saw the body, but failed to recognize her. Nobody knew the identity of the girl at first." McDonald returned home, "looked in the kitchen for signs of breakfast, failed to see anyone there, went to the girl's room and found it unoccupied, and rushed back to the school, and [only then was he] the first to recognize the victim."

Police believed Bessie was jumped as she passed the school and that she was gagged with a red bandanna handkerchief that was left behind by the killer before being dragged to the side of the building, out of view of passersby. Several residents who lived in the area told police they heard what may have been muffled screams or cries, but they couldn't be sure. They

Downtown Massena. *Courtesy of the St. Lawrence County Historical Association.*

thought perhaps it was kids goofing off or merrymakers, so they thought nothing more of it at the time. Two male witnesses said they heard what they thought was either a cat fight or kids hiding in the construction area trying to scare people as they walked past around 9 p.m. that night.

The *Watertown Daily Times* of October 6, 1917, said Bessie's body was found behind a pile of rubbish in the school yard just ten feet off the roadside by the project supervisor around 7 a.m., just as work crews had begun to arrive. The postmortem examination revealed that rape had been attempted before the victim was killed, and the "ground was marked by many evidences of a terrific struggle, showing that the woman fought desperately with the murderer." Either an iron bar or stick was believed to have been used in the attack. Bessie's skull over the left ear was crushed, there was a deep cut over her right eye, her nose had been broken, her right cheek was severely bruised, as were her hands and legs; and she suffered at least two broken fingers from warding off her attacker's blows. Her hat and umbrella were found nearby, stuffed inside of a brick and under a wheelbarrow, respectively. The *Times* reported that "a short distance from the body there was a fragment of knit underwear about 18 inches long" and said, "The clothing of the victim was badly torn and disarranged, which furnished mute testimony of the motive of the crime." The paper further speculated that the killer bludgeoned the

The high school on Bridges Avenue that was under construction when Bessie White was murdered. *Courtesy of the St. Lawrence County Historical Association.*

girl to death after failing in his attempt to sexually assault her, and then he fled the scene with the murder weapon, as none was found at the scene. He didn't take her purse, packages, ring or any of the jewelry she was wearing, so police believe the killer's only intent was sexual assault. All that was left behind as a clue, besides the battered body of his victim, was a man's red bandana handkerchief.

Along with the police chief who was called the moment the body was found, Coroner W.C. Smith, district attorney James Dolan and Sheriff Merton Farmer were promptly summoned to the scene.

The *Commercial Advertiser* of October 9, 1917, said:

> *A bloodhound was brought here from Dannemora prison and was taken to the scene of the murder. He was given the scent from the red bandanna handkerchief which was dropped at the scene of the crime and followed it as far as the fountain across the street, but there the dog lost the scent and was unable to pick it up. As 36 hours had elapsed after the crime was committed, little hope was held out that the dog would prove of assistance.*

One recent online article said that the dog made a beeline to the McDonald residence, which fueled speculation that the school superintendent was involved. But the original 1917 news articles I referenced said the dog went to the fountain across the street from the school, not to the McDonald home. And even if it had gone straight to the McDonald home, wouldn't that make sense anyway? If the bandana was used by the killer to stifle Bessie's cries, as believed, it would certainly have still had her scent on it—not just the killer's. And her scent would naturally lead the dog to that particular dwelling. Since the house was only forty or fifty yards away from the body (depending on the source), it's not surprising at all that the dog would head in that direction. It certainly doesn't incriminate McDonald.

At 10 a.m. the body was moved to the undertaking rooms of Fisher & Wiles for a postmortem examination, after which an official murder investigation was opened. A reward of $1,000 for information leading to the identity of the killer was offered: $500 from St. Lawrence County and $500 from the Town and Village of Massena. Another $3,000 was spent on additional lighting for the construction site where the body was found, removal of shade trees and additional, temporary mounted police. It was a lot of money in those days, but it produced no substantial leads. Because the Aluminum Company of America (Alcoa) had imported a

Elm Circle with the old water fountain where a dog followed the scent of a bandana from the crime scene. *Courtesy of the St. Lawrence County Historical Association.*

number of unsavory-type laborers to the area, as stated previously, it was widely believed that one of them might be responsible, so a search was conducted among employees of the company. The *Watertown Re-Union* of October 16, 1917, said of the laborers, "Of this number, about 200 are Negroes, and others are recruited from the lowest stratum of society." All eyes were thus focused for the moment on the transient labor force. Locals were so certain at first that an Alcoa laborer must have committed the deed that the *Watertown Herald* of the same date said (all in the same paragraph):

> *It was only on Wednesday of this week that Bessie White, 22 years old, of Maple Ridge, met death at the hands of an unknown assailant, almost in the heart of the village of Massena. The police records at Ogdensburg teem with reports of infractions of the law on the part of Aluminum company employees.*

The same paper three days earlier had said, "It is a fair supposition that if it is found that the assailant was one of the East St. Louis Negroes imported by the Aluminum Company that the Northern New York mind will view

with clearer understanding the anti-negro rioting in Illinois." But it wasn't just Alcoa's employees who were under the microscope. The venerable Mr. McDonald—Bessie's employer of three months—was also subjected to rumor and ridicule, after an article implicating his involvement was published in a daily Ogdensburg newspaper.

The *Courier & Freeman* of November 14, 1917, said:

> *An Ogdensburg daily newspaper the other day published a most improbable story in this connection and the entire staff of this paper was subpoenaed to Massena Saturday to tell where they got the information on which the story was based. They acknowledged it was only rumor and had no foundation in fact, and they promised to make a complete statement to the effect, which they did in the Sunday issue.*
>
> *Mr. McDonald…spent the entire evening of the murder at the Citizen's Club in this village, and he is able to prove that fact by more than half a dozen of the businessmen in town who were also there at the time. He left the Club in company with James B. Kirkbride just before ten o'clock and went directly home, having no knowledge of the crime until the next morning.*

Other local papers, too, like the *Massena Observer* (of which McDonald was co-owner until 1906), the *Malone Farmer*, and the *Courier & Freeman*, quickly came to McDonald's defense. The *Observer* said, "Mr. McDonald needed no alibi in Massena to prove his innocence, and how or why these malicious stories were circulated cannot be imagined. Meantime, there is no trace of the real murderer of Bessie White." And the *Commercial Advertiser* from Canton lent its support and outrage, saying:

> *Men of character testified to having been with Mr. McDonald at the Citizen's Club at Massena as late as 9:30 on the night of the tragedy; and one of these told of accompanying McDonald as far as his home…A reporter on the Ogdensburg News was sworn and stated that the story published had no foundation other than rumors and hearsay that was floating about. The News, in an issue following the hearing, stated that the publication was entirely lacking of foundation.*
>
> *It is very evident that all stories of this nature have been idle gossip told and repeated by people who evidently did not realize the horrible opprobrium and infamy that was being cast upon an entirely innocent man who had lived*

an open and upright life. Mr. McDonald has done the proper thing—in proceeding in a legal way to not only scotch the snake, but kill it. He has also the satisfaction of knowing that he has a very wide circle of friends who have believed in him, though the tongue of rumor wagged viciously.

While McDonald was fending off false accusations, authorities began running down clues and chasing leads. A Russian laborer who left Massena immediately following the murder, for example, was traced to the town of Madrid and then in the opposite direction toward St. Regis Falls. He was soon cleared of any involvement. Feeble-minded Herman Whymss, an African American, was taken into custody in the city of Syracuse and questioned; he, too, was cleared since he had been in the St. Lawrence County jail at the time of the murder. Syracuse police brought in a homeless person named George Brice, after finding some soiled, discarded clothing belonging to him. Brice insisted he had not been in Massena for two or three years, and he, too, was released. The following year, on September 10, 1918, the *Commercial Advertiser* and other area papers reported that an African American convict named Will Thomas claimed to know who killed Bessie White. According to the *Massena Observer*, Thomas's statement could be the tip authorities had been waiting for.

On September 12, 1918, the paper reported:

August 29, Police Captain F. J. Stubbs received a letter from J. H. Bair, of Akron, Ohio, deputy sheriff of Summit County, asking for information regarding a murder committed in Massena on October 3, 1917, because he had a man in jail claiming to know all about the case. Stubbs provided the information, then received a letter dated August 31, saying that his prisoner said "the man who did it was a white nigger named Frank whose last name the prisoner did not know, but who was a cement worker by trade and worked for the Aluminum Company of America."

He and Frank, he said, shared sleeping quarters in "one of a row of ten houses the company had built near building No. 12" at the time of the murder. They resided in the third house from the river. On October 5, 1917, Thomas claimed that he had been paid forty dollars to wash blood out of Frank's clothing. Frank had straight, black hair and gray eyes, a long face and yellowish skin, according to Thomas. He was around forty years old and a good-size man by yesteryear's standards (170 pounds and slim).

Thomas told police:

> *This girl was killed on Wednesday night…which was pay day, at which time I was on the night shift. I generally did Frank's washing, but did not wash on Thursday, and on Friday I started to wash and I asked Frank what the little specks of blood on his shirt were, at which time Frank told me that it was alright; that I was old enough to be his father and he would tell me, but he did not tell.*
>
> *That Friday night, Frank went to sleep and started to talk in his sleep about what he had done. I put his hands in some water, and he started to tell that he killed this girl, that he assaulted this girl and then killed her, and wouldn't have anybody know it on earth; he said he sure done it but he wouldn't have it known for nothing on earth.*
>
> *The next morning, I got at Frank about what he had been talking about, and I said, "Listen, man, let me tell you one thing. These white folks around here will kill you, and they will kill every nigger on earth." Frank said nobody on earth knows this but me, but are you sure I said that last night?" I said, "I know you did it. I stayed in the room with you." I then told Frank there were three or four fellows that stayed in the next room and that there were some other fellows who wanted to come in and board with him and me in this room, but I told him if he wanted to talk like that in his sleep, we could not have nobody else stay in this room. Frank told me to keep my mouth shut, and I told him I would say nothing about it.*
>
> *There was blood on Frank's sweater, and I asked him what he was going to do about that, and he said he worked every day and got it all messed up…and he would cut out the blood spots and I could wash it, which I did.…Every day when I came home, Frank would buy me whiskey and tell me for God Almighty sake not to say anything about it.*

Thomas claimed that both he and Frank had come from Cleveland, Ohio, to work at Alcoa. When Thomas left Massena, he told authorities that Frank promised to pay him $150 to keep quiet—$40 of which he had paid on the spot; and the rest of which was to be forthcoming. As hopeful as authorities were that this was the break they had been waiting for, their hopes were shattered when Thomas admitted he had lied. The *Norwood News* of October 2, 1918, announced, "The negro finally told the authorities that he had lied about the matter and knew nothing about the crime." He claimed he

believed that fabricating such a story might improve his chances of being released from prison on charges of killing a woman in Louisiana and hitting another woman in the head with a stone in Ohio.

Though countless individuals have attempted to solve the Bessie White murder mystery, nobody to date has found the answer to Massena's most enduring enigma:

Who killed Bessie White?

BIBLIOGRAPHY

BOOKS & REPORTS

Curtis, Gates. *Our County and Its People: A Memorial Record of St. Lawrence County, New York*. Syracuse, NY: D. Mason, 1894.

Durant, Samuel W. and Henry B. Pierce. *History of St. Lawrence Co., New York with Illustrations and Biographical Sketches of Some of Its Prominent Men and Pioneers*. Philadelphia: L.H. Everts, 1878.

Everts, L.H. and J.M. Holcomb, *History of St. Lawrence County, New York*. Philadelphia: L.H. Everts & Co., 1878.

Hough, Franklin Benjamin. *A History of St. Lawrence and Franklin Counties, New York: From the Earliest Period to the Present Time*. Albany, NY: Little, 1853.

People v. Conroy. Vol. 47, *The Northeastern Reporter*. St. Paul, MN: West Publishing Co., 1897.

The Trial for Murder of James E. Eldredge, Convicted of Poisoning Sarah Jane Gould. Ogdensburg, NY: Hitchcock, Tillotson & Stilwell's Steam Presses, 1857.

NEWSPAPERS

Advance News. "Conroy Homicide Recalled." August 30, 1953.

———— "Conroy Wife Murder Occurred in West Side House Half Century Ago." June 8, 1947.

———. "Dr. Smith Had Brush With Death." March 11, 1949.

———. "Murders Long Ago Recalled." March 25, 1956.

Alexander, W.M. "History Raises Question If Gould Murder Conviction Was First in St. Lawrence." *Massena Observer*. March 4, 1938.

Commercial Advertiser. "Buckton's Awful Tragedy." April 4, 1905.

———. "Driggs Goes to Death House." November 6, 1917.

———. "First Murderer Executed in County." November 20, 1917.

———. "Foul Murder at Massena." October 9, 1917.

———. Note regarding Frank Driggs. August 14, 1917.

———. "Stories Implicating Massena Man in White Murder Baseless." October 9, 1917.

———. "Will Thomas Solve Mystery." September 10, 1918.

Courier & Freeman. "Alvah Briggs Goes to Chair." June 19, 1918.

———. "Brutal Murder of Massena Girl." October 10, 1917.

———. "The Driggs Murder." June 27, 1917.

———. "The Evidence in the Case." November 7, 1917.

———. "Frank Driggs an Ex-Convict." August 8, 1917.

———. "Investigation in Murder." November 14, 1917.

———. "Murdered His Wife with a Butcher Knife." May 27, 1896.

———. "Murderer Still Untraced." October 17, 1917.

———. "Murder in 2nd Degree." September 16, 1908.

———. "New Clue in Massena Murder." September 1917.

———. Note regarding Maria Shay's death. October 20, 1870.

———. "Rapid Progress in Murder Trial." October 31, 1917.

———. "Summary by Mr. Donavin." November 7, 1917.

Courier-Observer. "Combs Guilty of Murder." 1909.

Franklin Gazette. Note regarding Van Dyke. December 28, 1877.

Free Press. "Death Chair for Him." August 12, 1896.

———. "Double Murder at Black Lake." May 13, 1908.

———. Note about Conroy. May 27, 1896.

Gouverneur Free Press. "Rollin Dunning Serving Thirty Days In Canton." February 1, 1928.

Hammond Advertiser. "Robberies May Be Cleared Up." October 9, 1924.

Kevlin, James. "Rough, Rugged Early Days Spawn Gruesome Murder." *Watertown Daily Times*. October 30, 1980.

Landy, Becky and Colleen Brown. "Two 1800 Murders Discussed." *Courier & Freeman*. March 2, 1976.

Liebler, Shane M. "Fire Department Given Old Massena Restaurant." *Watertown Daily Times*. November 9, 2006.

―――. "New Owner Will Raze Former Massena Eatery." *Watertown Daily Times*. July 20, 2006.

Madrid Herald. "Alcohol Fiend Kills Four People." June 28, 1917.

Massena Observer. "Burrell and Kipps Held for Trial." September 29, 1904.

―――. "Burrell at Liberty." August 4, 1904.

―――. "Burrell on Trial for Killing Kipp." December 15, 1904.

―――. "Combs Sentenced to Electric Chair." January 14, 1909.

―――. "Fred Casaw Died Monday." February 9, 1956.

―――. "Hearing in Kipp Murder Case." July 21, 1904.

―――. "A Jealous Brother Murders and Suicides." April 6, 1905.

―――. "LaDue Girl Tells of Awful Murder." November 1, 1917.

―――. "Louisville Scene of 1816 Murder." September 25, 1924.

―――. "May Be Murderer of Bessie White." September 12, 1918.

―――. "Mrs. Carrie Kipp Confesses Crime." August 11, 1904.

―――. "Mrs. Kipp is Sick." July 21, 1904.

―――. Note regarding Bessie White funeral. October 11, 1917.

―――. Note regarding Hall house fire. March 30, 1905.

―――. "Obituary—James Scarborough." March 13, 1913.

―――. "Obituary—Mary White." May 13, 1920.

―――. "Obituary—Mrs. Amab Casaw." October 2, 1913.

―――. "Probing White Murder Mystery." November 8, 1917.

―――. "Trial of John Burrell for Murder of Kipp." December 22, 1904.

―――. "Trial of John Burrell for Murder of Kipp." December 29, 1904.

―――. "Two More Arrests in the Kipp Case." July 7, 1904.

―――. "Unsolved Murder to Be Discussed." March 9, 1989.

―――. "Wants $15,000 Damages." June 15, 1905.

New York Times. "Girl Mysteriously Slain." October 5, 1917.

―――. Note regarding Conroy's execution. August 11, 1897.

Northern Tribune. "A Foul Murder: Frank Conroy Stabs and Kills His Wife." May 22, 1896.

―――. "Life Prisoner Out on Parole." September 26, 1923.

Norwood News. "A Brutal Murder." October 6, 1908.

―――. "Conroy Before the Court." August 11, 1896.

―――. "Conroy Must Die." June 15, 1897.

―――. "James M. Scarborough." March 19, 1913.

———. "Murder and Suicide." April 4, 1905.

———. Note regarding Bessie White. October 2, 1918.

———. Note regarding Mrs. Sumner Hazen. November 21, 1899.

———. Note regarding Rollin Dunning. October 3, 1899.

Ogdensburg Advance. "Buckton Double Tragedy." April 5, 1905.

———. "Driggs to Die at Sing Sing Dec. 10." December 6, 1917.

———. "The Gallows—Van Dyke Hung on Friday." 1877.

———. Note regarding Bessie White. March 1, 1917.

———. Note regarding the birth of Sumner Hazen's daughter. August 12, 1897.

———. "Van Dyke Murder Trial." October 30, 1877.

Ogdensburg News. "Beautiful Massena Girl Murdered by Negro Fiend Who Attacks Her!" October 5, 1917.

———. "No Evidence Obtainable That Negro Held in Jail Here is Guilty." October 7, 1917.

Potsdam Herald-Recorder. "Murder at Fine." October 2, 1908.

———. "Will Slayer Be Now Found?" September 13, 1918.

Republican (Plattsburgh, NY). Note regarding Scarborough murder case, March 2, 1816.

———. "Shocking Murder." February 24, 1816.

Republican (St. Lawrence, NY). "The Abortion Murder Case." March 26, 1872.

———. "Acquittal of Dr. McMonagle." October 18, 1870.

———. "Acquittal of the Farnsworth Brothers and Halsey Smith." April 14, 1874.

———. "Another Abortion Murder in Ogdensburg." March 19, 1872.

———. "Another Murder in St. Lawrence County." January 30, 1872.

———. "The Case of Dr. Mongeon." March 17, 1874.

———. "Closing Scenes of the Late Murder Trial of James E. Eldredge."

———. "Court Proceeding" (regarding Farnsworth murder). April 14, 1874.

———. "The Execution of Van Van Dyke." December 26, 1877.

———. "The Farnsworth Murder Case." April 7, 1874.

———. "The First Execution in St. Lawrence County." December 14, 1881.

———. "The Hermon Poisoning Case." February 6, 1872.

———. "The Late Murder Trial." January 5, 1858.

———. "A Malicious Statement." May 14, 1872.

———. "Murder in Louisville." June 16, 1857.

———. Note regarding John Walsh's murder. February 8, 1882.

————. Note regarding Maria Shay's death. January 24, 1877.

————. Note regarding Sarah Gould's poisoning, February 4, 1861.

————. "Reminiscences of the Burg." January 24, 1871.

St. Lawrence Republican. "Cold-Blooded Murder." September 30, 1908.

————. "Combs Goes Calmly to the Death Chair." February 17, 1909.

————. "Combs' Last Hours." February 24, 1909.

————. "Combs Near to Death." February 10, 1909.

————. "Combs Safe at Canton." October 7, 1908.

————. "Combs Tells of Poison." January 20, 1909.

————. "The Conroy Murder!" May 27, 1896.

————. "Conroy's Story of His Crime." June 3, 1896.

————. "Evidences of Murder Found in Investigating the Death of Joseph Kipp." May 4, 1904.

————. "Jury Box is Filled." January 6, 1909.

————. Note regarding John Burrell's trial for Kipp murder. January 4, 1905.

————. Note regarding Leslie Combs. January 13, 1909.

————. Note regarding Maria Shay's death. April 30, 1872.

————. Note regarding Mrs. Sumner Hazen's death. July 27, 1900.

————. Note regarding Scarborough murder case. December 26, 1877.

————. Note regarding Scarborough murder case. December 14, 1881.

————. "Sentenced to Death. Leslie Combs Found Guilty of Murder, 1st Degree." January 13, 1909.

————. "The Tragedy at Buckton." April 5, 1905.

————. "Will Be No Appeal: Combs Said to be Willing to Meet Fate." January 13, 1909.

————. "Woods, the Murderer." January 9, 1878.

St. Lawrence Weekly Democrat. "Triple Headed Murder." December 15, 1904.

Town and County. Note regarding Maria Shay's death. October 22, 1870.

Tyler, Elsie H. "History Re-Visited During Our Bicentennial." *Tribune-Press.* March 24, 1976.

Utica Daily Observer. Note regarding Maria Shay murder case. April 3, 1872.

Utica Saturday Globe. "Murder at Fine." January 2, 1909.

————. "Pictorial Story of a Crime." January 9, 1909.

Watertown Herald. Note regarding Bessie White. October 6, 1917.

————. Note regarding Bessie White. October 13, 1917.

Watertown Re-Union. "Massena Girl is Murdered." October 6, 1917.

————. "Terrible Crime at Black Lake." May 13, 1908.

ONLINE SOURCES

"Comstock Laws." Wikipedia, the free encyclopedia. http://en.wikipedia. org/wiki/Comstock_laws.

Gibson, C. Michael and Cafer Zorkun. "Strychnine poisoning." Wiki doc. http://wikidoc.org/index.php/Strychnine_poisoning.

Google Maps. http://maps.google.com/.

"Harriet A. Farnsworth Death." The Farnsworth Family of Camden. http://www.dfarns.com/farnsworth/timeline/f19020403.asp.

"History of Abortion." Wikipedia, the free encyclopedia. http:// en.wikipedia.org/wiki/History_of_abortion.

"Home Page." Comstock Law of (1873). http://law.jrank.org/pages/5508/ Comstock-Law-1873.html.

Keene, Michael. "19th Century Abortions." Buzzle—Intelligent Life on the Web. http://www.buzzle.com/articles/19th-century-abortions.html.

Lewis, Jone Johnson. "Abortion History." About.com Women's History. http://womenshistory.about.com/od/abortionuslegal/a/abortion.htm.

Northern New York Historical Newspapers. http://news.nnyln.net/.

"Punishing Illegal Abortion." Abort73.com. http://www.abort73.com/ end_abortion/punishing_illegal_abortion/.

Pylant, James. "Abortion in the 19th Century." Genealogy Magazine. http:// www.genealogymagazine.com/abortion1.html.

"Strychnine poisoning." Wikipedia, the free encyclopedia. http:// en.wikipedia.org/wiki/Strychnine_poisoning.

ABOUT THE AUTHOR

Cheri Farnsworth has written the following titles (some under the name of Cheri Revai): *Haunted Northern New York* (Vol. 1–4, 2002–2010), *Haunted Massachusetts* (2005), *Haunted New York* (2005), *Haunted Connecticut* (2006), *Haunted New York City* (2008), *The Big Book of New York Ghost Stories* (2009), *Haunted Hudson Valley* (2010), *Adirondack Enigma: The Depraved Intellect and Mysterious Life of North Country Wife Killer Henry Debosnys* (2010), and *Alphabet Killer: The True Story of the "Double Initial" Murders* (2010).

Author Cheri L. Farnsworth with Coco. *Courtesy of Jamie Revai.*

She enjoys researching regional history, true crime and the connection between history, crime and the paranormal. Farnsworth lives in St. Lawrence County with her husband, four daughters and a menagerie of pets.

Visit us at

www.historypress.net